W9-BXM-789

DRAW **50** ANIMAL 'TOONS

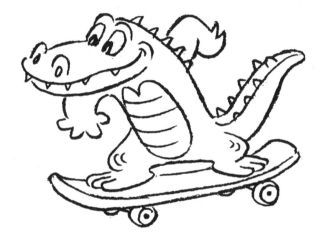

BOOKS IN THIS SERIES

DRAW 50 ANIMAL 'TOONS

Lee J. Ames
and Bob Singer

BROADWAY BOOKS

NEW YORK

BROADWAY

DRAW 50 ANIMAL 'TOONS. Copyright © 2000 by Lee J. Ames and Murray Zak. All rights reserved.
Printed in the United States of America. No part of this book may be reproduced or transmitted
in any form or by any means, electronic or mechanical, including photocopying, recording, or
by any information storage and retrieval system, without written permission from the publisher.
For information, address Broadway Books, a division of Random House, Inc., 1540 Broadway,
New York, NY 10036.

Broadway Books titles may be purchased for business or promotional use or for special sales.
For information, please write to: Special Markets Department, Random House, Inc., 1540 Broadway,
New York, NY 10036.

BROADWAY BOOKS and its logo, a letter B bisected on the diagonal, are trademarks of Broadway Books,
a division of Random House, Inc.

Visit our website at www.broadwaybooks.com

The Library of Congress has cataloged this book as follows:

Ames, Lee J.
 Draw 50 animal 'toons / Lee Ames and Murray Zak—1st ed.
 p. cm.
 1. Cartooning—Technique. 2. Animals—Caricatures and cartoons. I. Zak, Murray. II.
 Title.
 NC1764.8.A54 A47 2000
 741.5—dc21 00-020750

ISBN 0-7679-0544-X

03 04 10 9 8 7 6 5 4 3

This book is dedicated to my dear wife Harriet,
Our five children,
Six grandchildren,
And to the "hummers," you know who you are!
—Lee J. Ames

Introduction
Drawing Tips

The lessons in this book show you how to draw cartoon animals. You can start anywhere in the book you like. Simply select a cartoon and follow the step-by-step method shown to create your drawing of it. On a separate piece of paper, very lightly and carefully sketch out step one. Although this step is the easiest, it is also the most important and should be done the most carefully. Step two shows you how to build on step one by adding sketching. This should also be done lightly and very carefully. Step three is lightly added right on top of step two. Continue this way to step four, the last step, which should be drawn firmly!

It may seem strange to ask you to be extracareful when you are drawing what seem to be the easiest first steps, but this is most important. A careless mistake at the beginning may spoil the whole picture at the end. As you sketch out each step, watch the spaces between the lines, as well as the lines, and see that they are the same as in the book. After each step, you may want to lighten your work by pressing it gently with a kneaded eraser (available at art supply stores). Just lighten the portions that have become too dark, don't make your lines invisible!

When you have finished your drawing, go over the final step in india ink with a fine brush or pen. When the ink is dry, use the kneaded eraser to clean off the pencil lines. The eraser will not affect the india ink. This is the way professional illustrators work.

Here are some suggestions: In the first few steps, hold your work up to a mirror. Sometimes the mirror shows that you've twisted or distorted the drawing off to one side without being aware of it. At first you may find it difficult to draw the lines, the egg shapes, the ball shapes, or sausage shapes, or to just make the pencil go where you wish. Don't be discouraged. The more you practice, the more you will develop control.

Although the only equipment you need to create beautiful drawings is a medium or soft pencil, paper, the kneaded eraser, and, if you wish, a pen or fine-pointed brush, you may also want to try using the Draw 50 series with your computer. The best way to use the Draw 50 series with a computer is with an electronic pencil and pad program, such as artPadII, Dabbler, or Painter (#4 or 5). Computers offer some advantages, not the least of which is the "Undo" command (not available with regular india ink!). On a computer, you can erase as many times as you wish without damaging the "paper" and you can print as many copies of your drawing as you like. You may also want to draw your images

using pencil and paper, then use a scanner to create an electronic version you can color and manipulate with a painting program.

There are many ways and methods to make drawings. My books show some of my favorite methods. There are other books—like those by my friend Mark Kistler—that show other exciting techniques. If you enjoy the Draw 50 series, I urge you to explore other ways to draw from teachers, from libraries, and most important . . . from inside your own imagination.

—LEE J. AMES

DRAW 50 ANIMAL 'TOONS

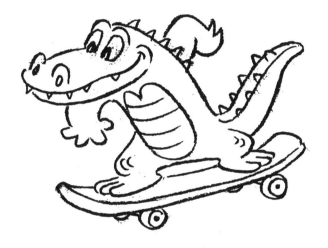

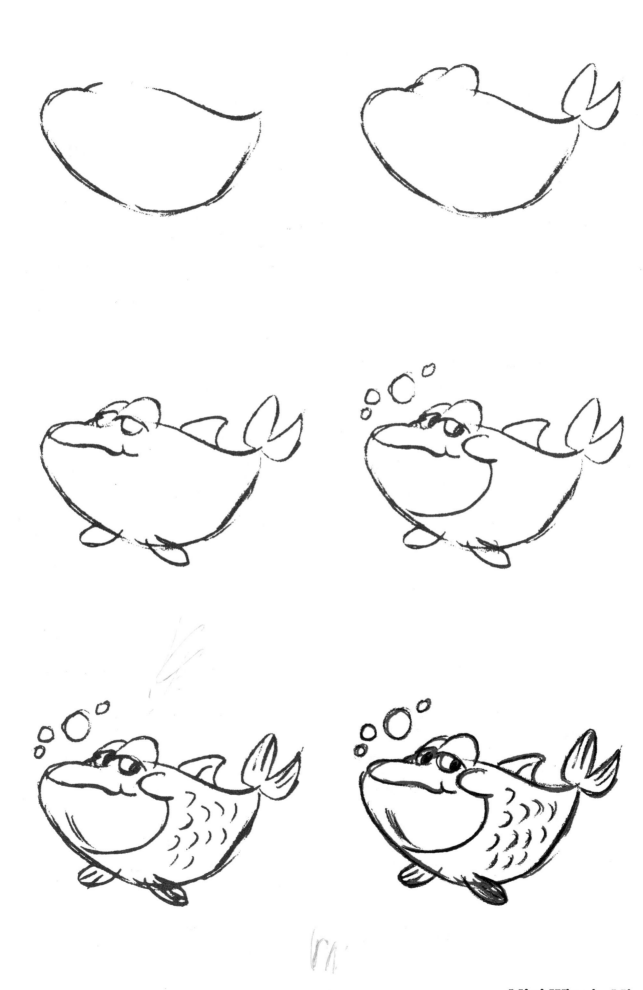

Mini Winnie Minnow

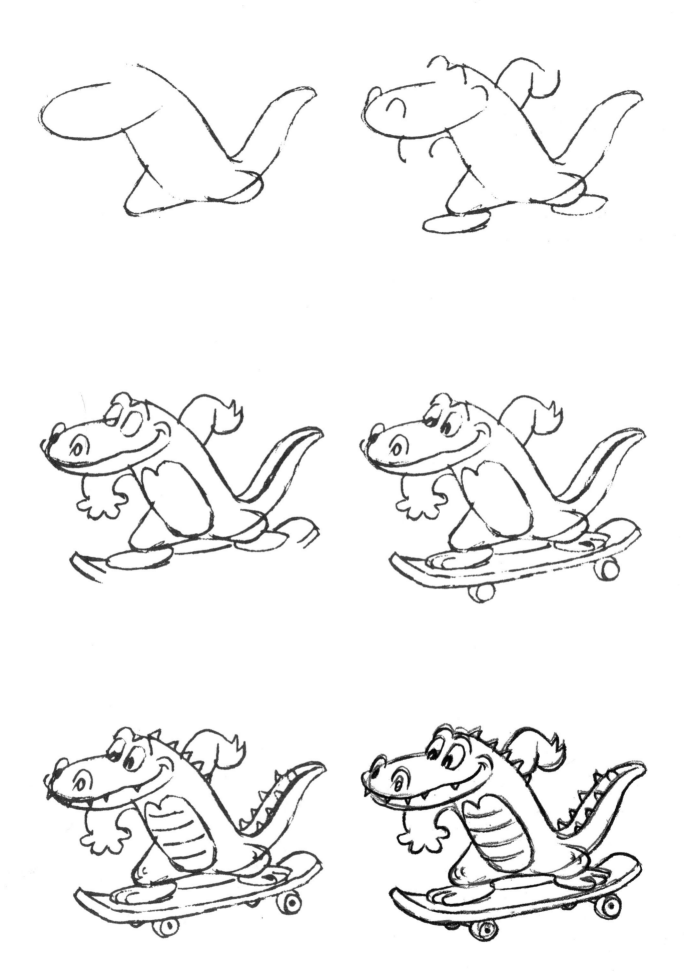

Al E. Skater

Emil McNeil, the Juggling Seal

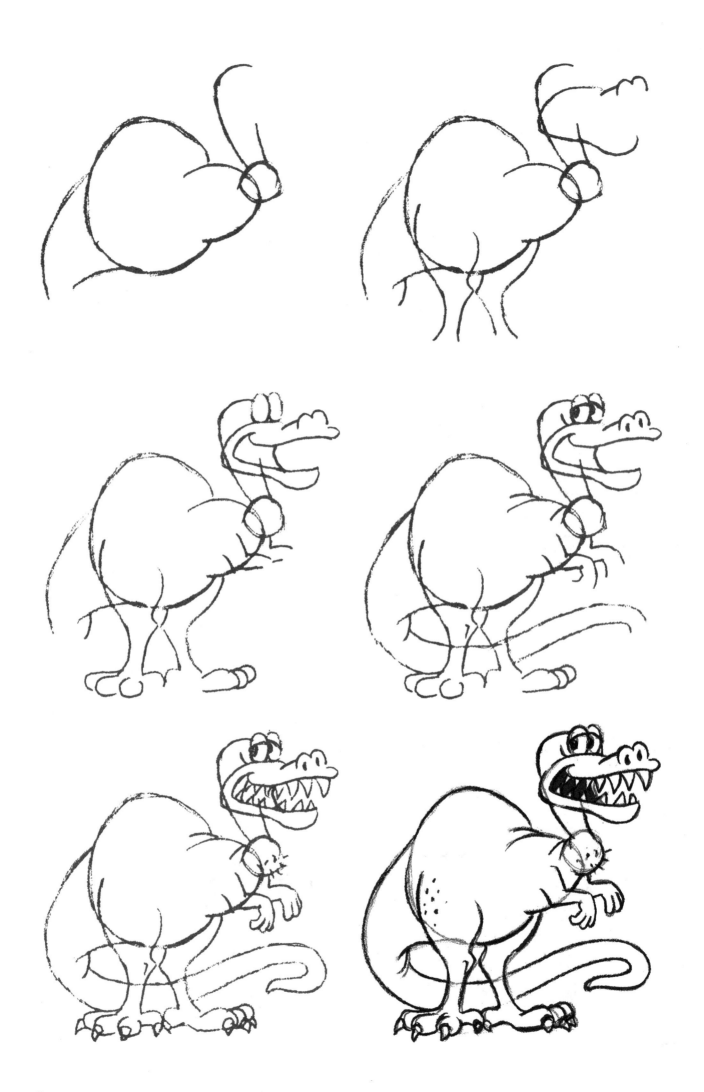

Danny Sore

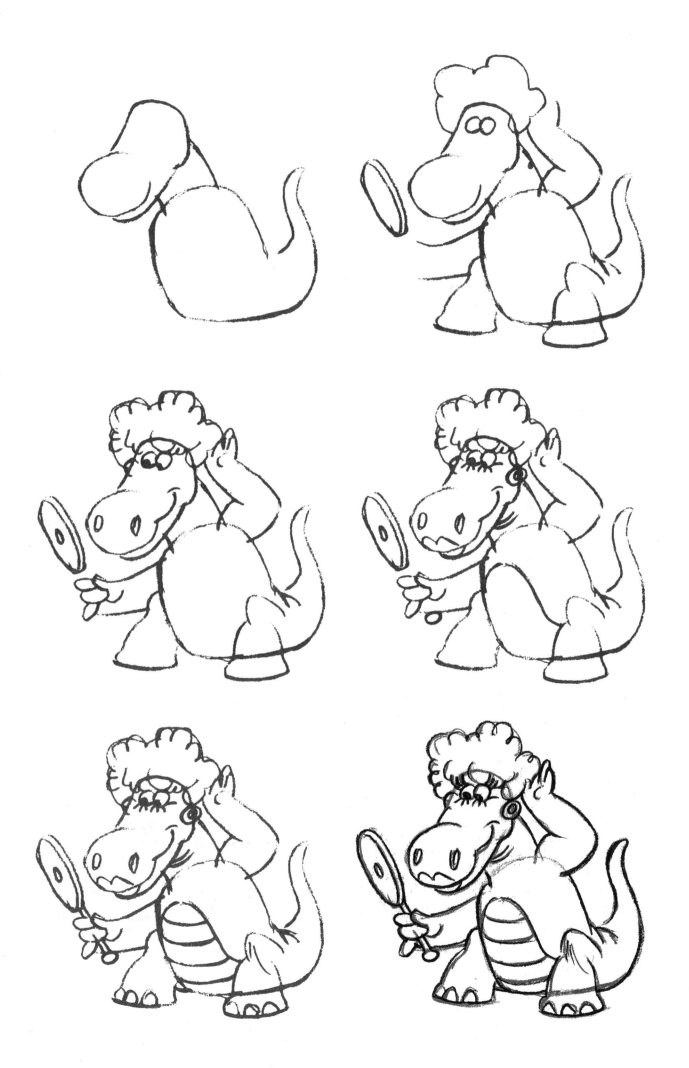

Dinah Soar

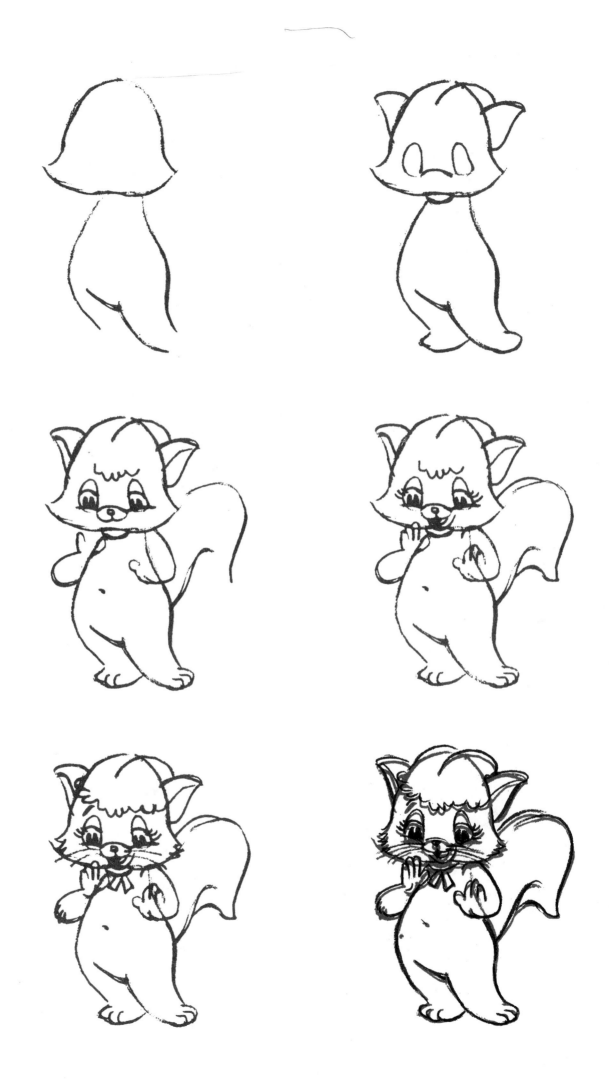

Kitty Little

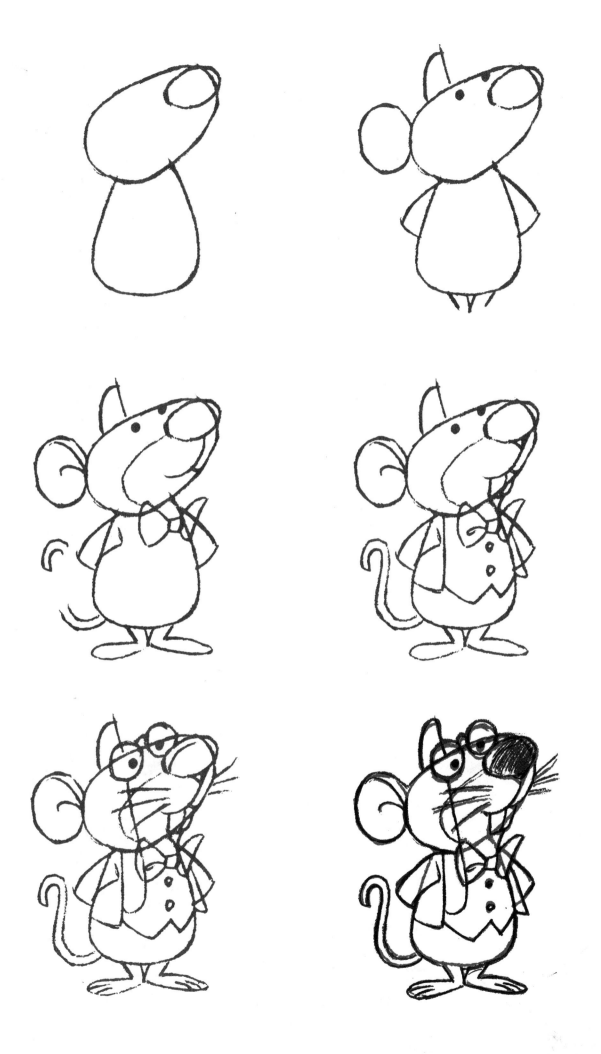

Professor Squeaks

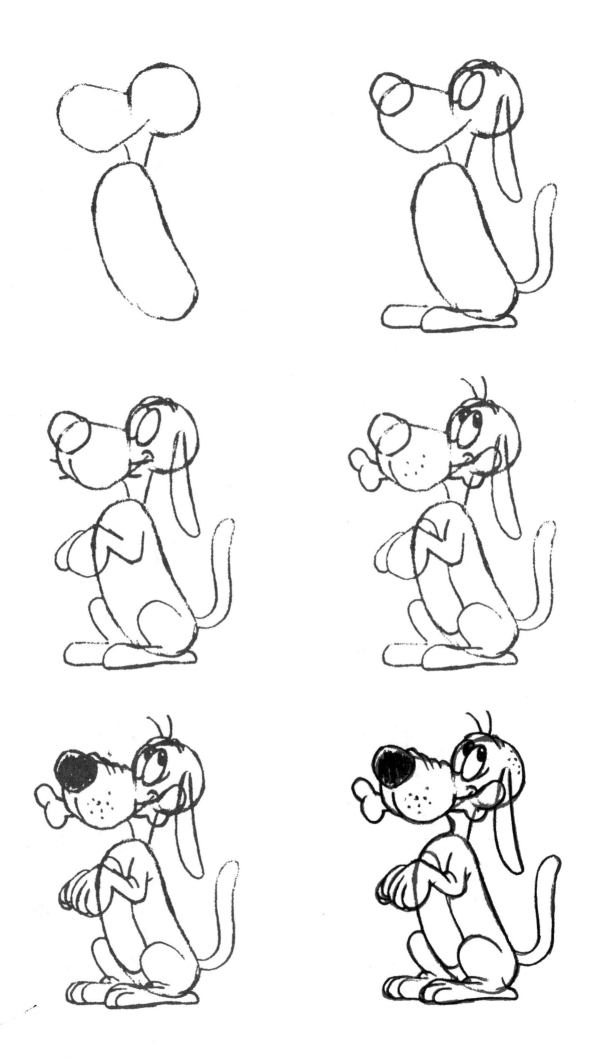

Buddy Beaglebeggar

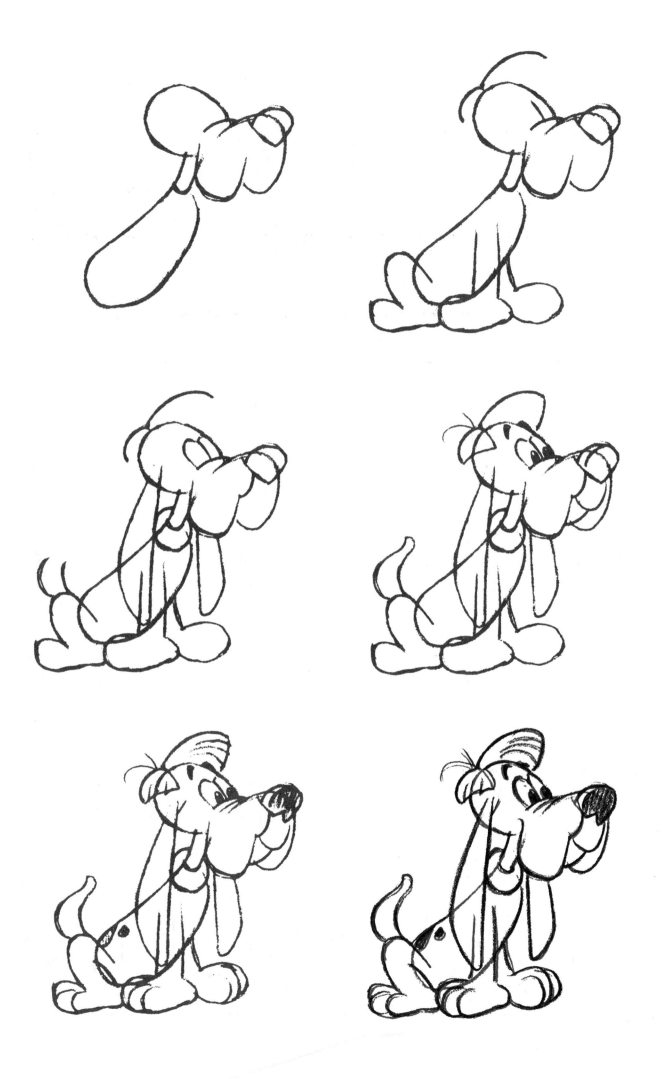

Smoochy Pooch

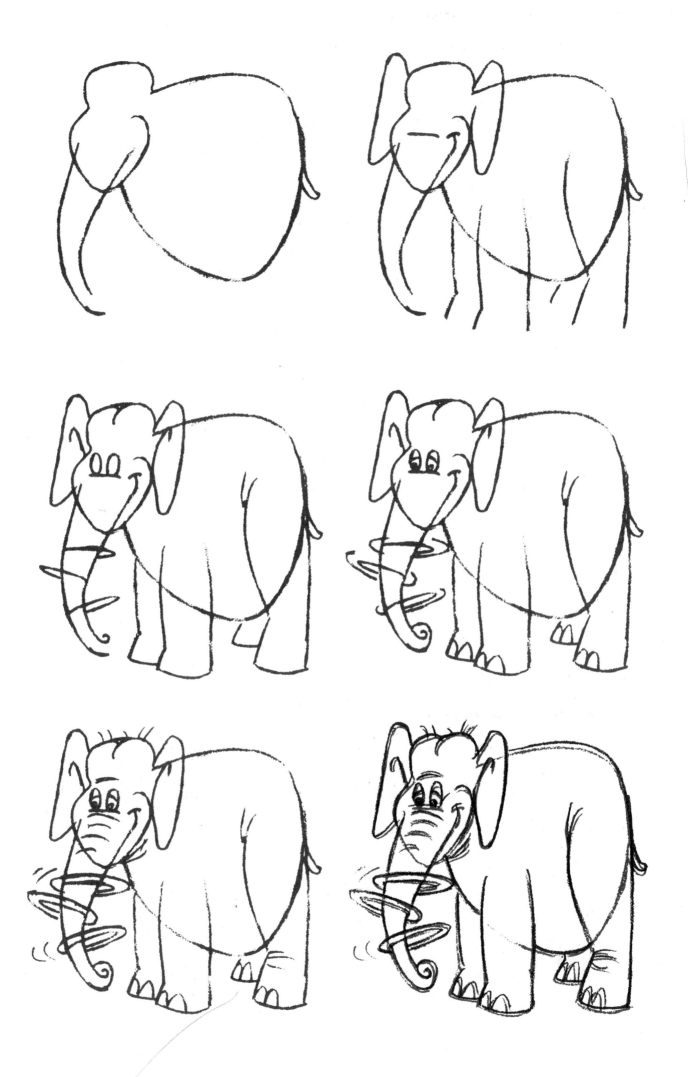

Hoop Spinner, L. F. Aunt

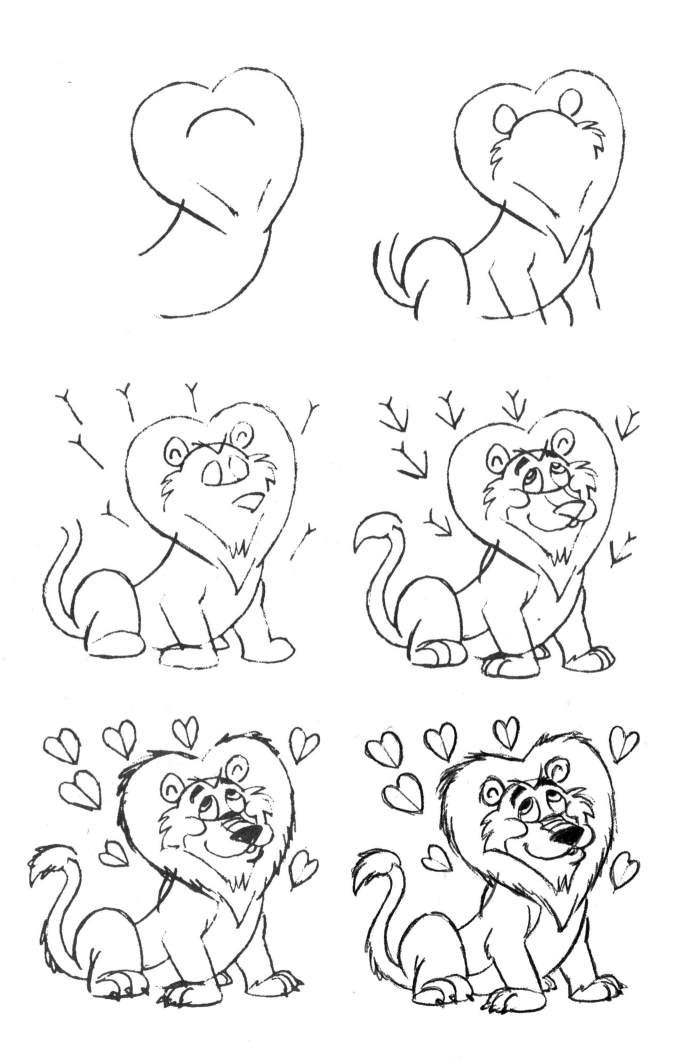

Lover Leo

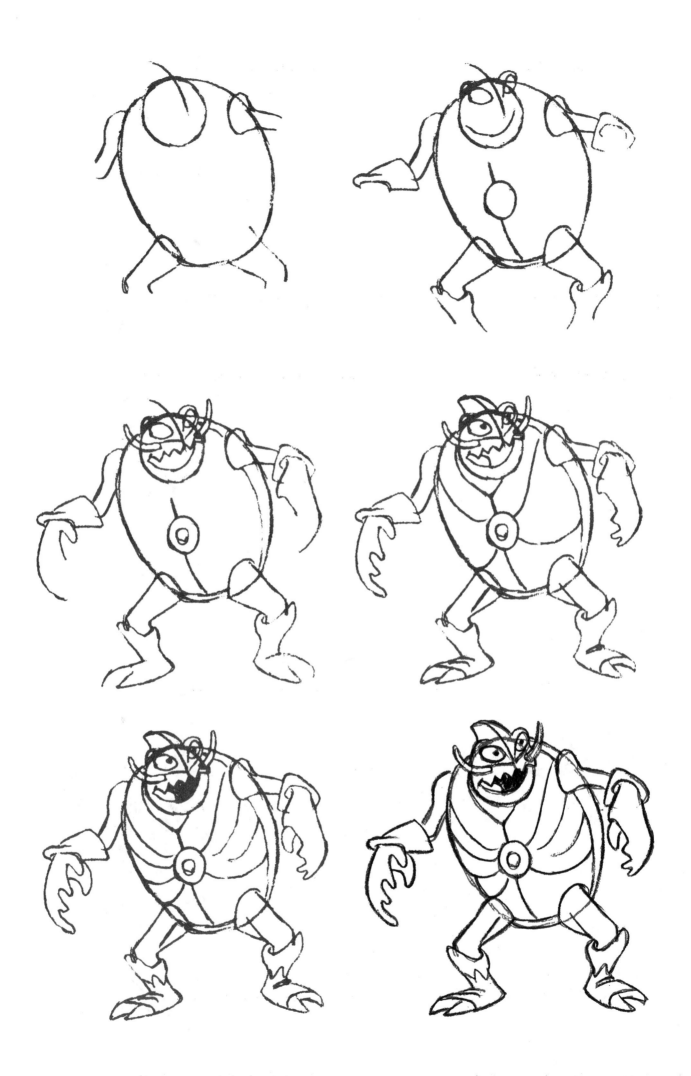

Brutal Beetle Boo

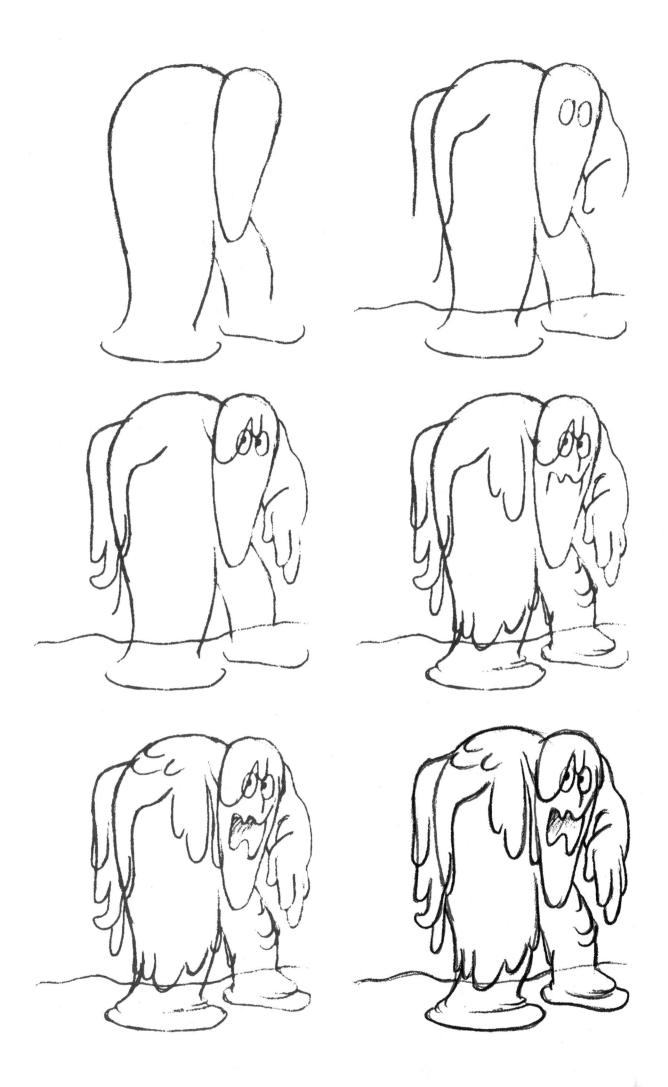

Mel Ted Goop

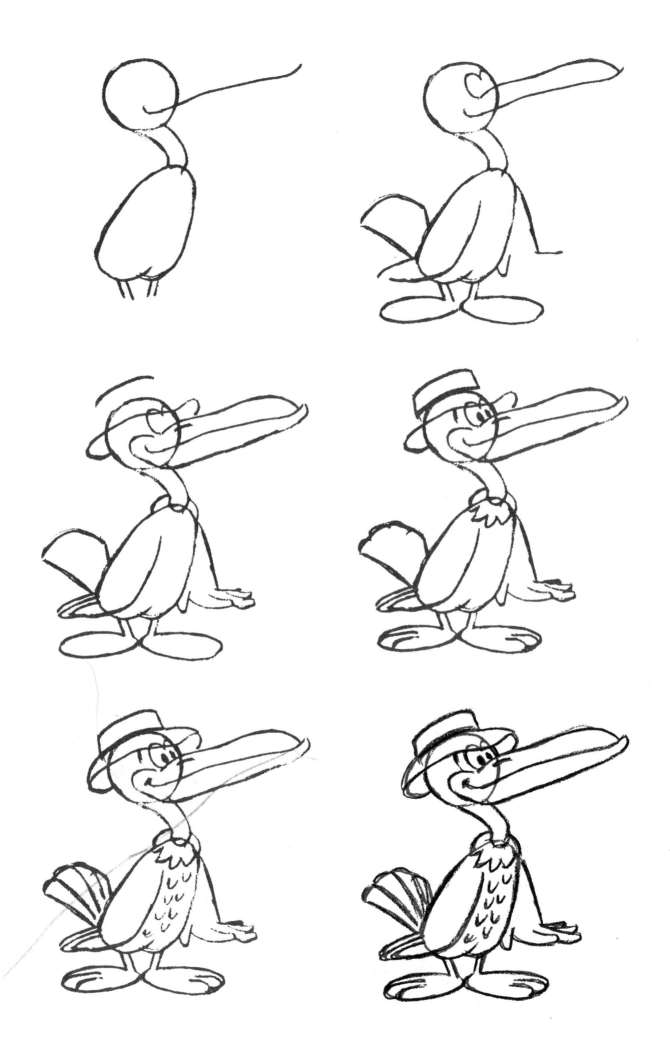

Pelican Pete with the Chic Beak

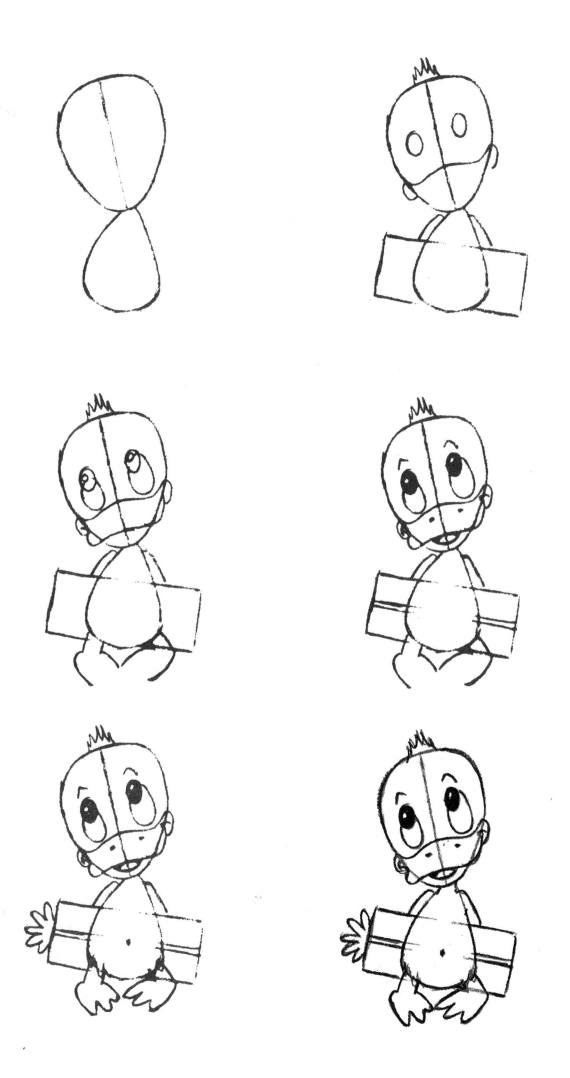

Cheepy Chicklette

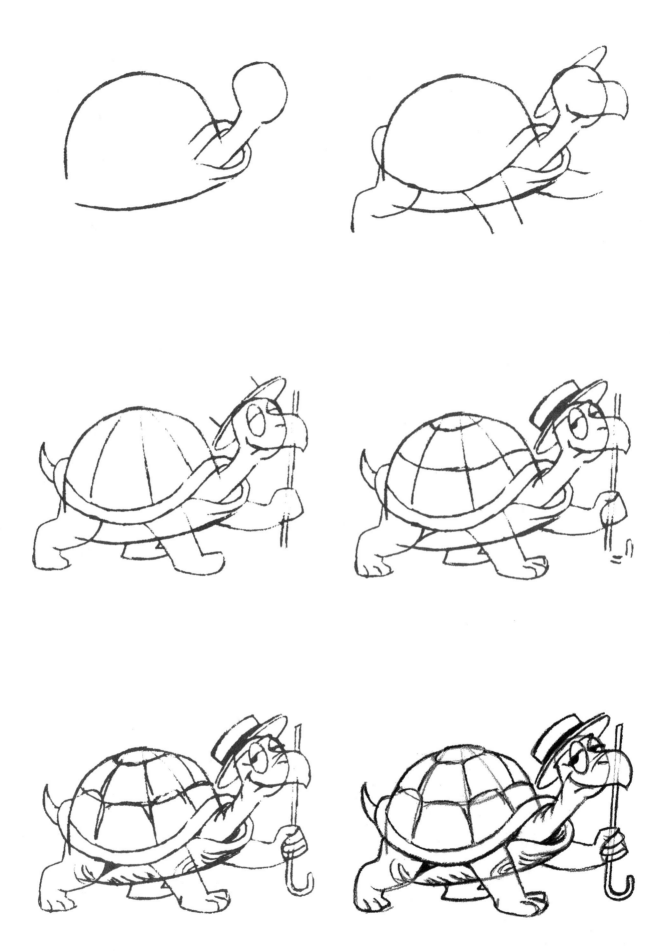

Burt L. Turtle

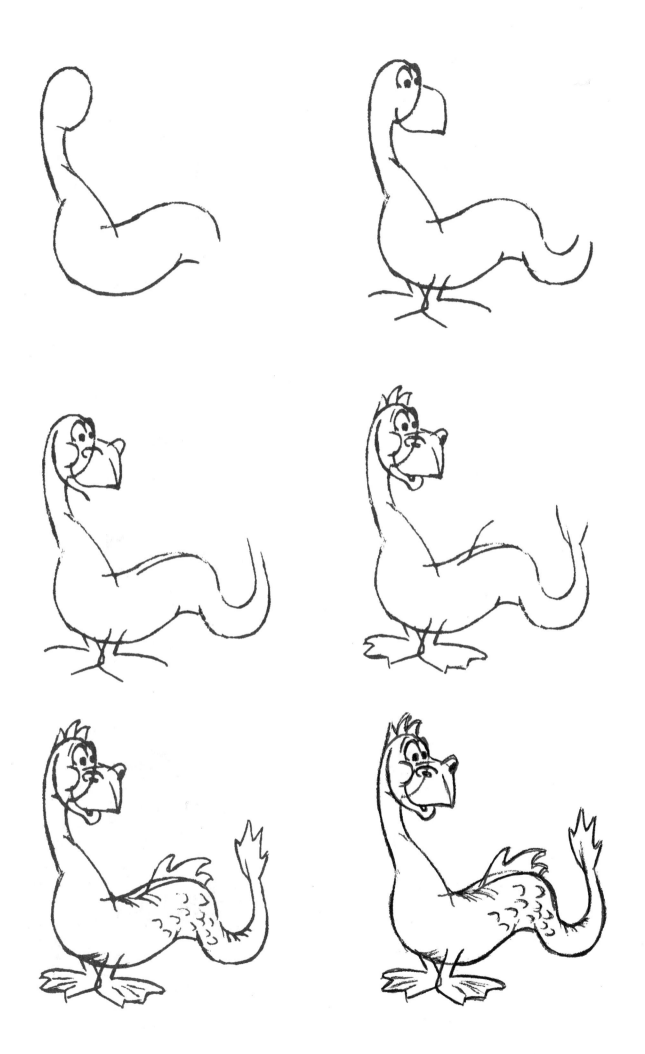

Sybil Sea Monster

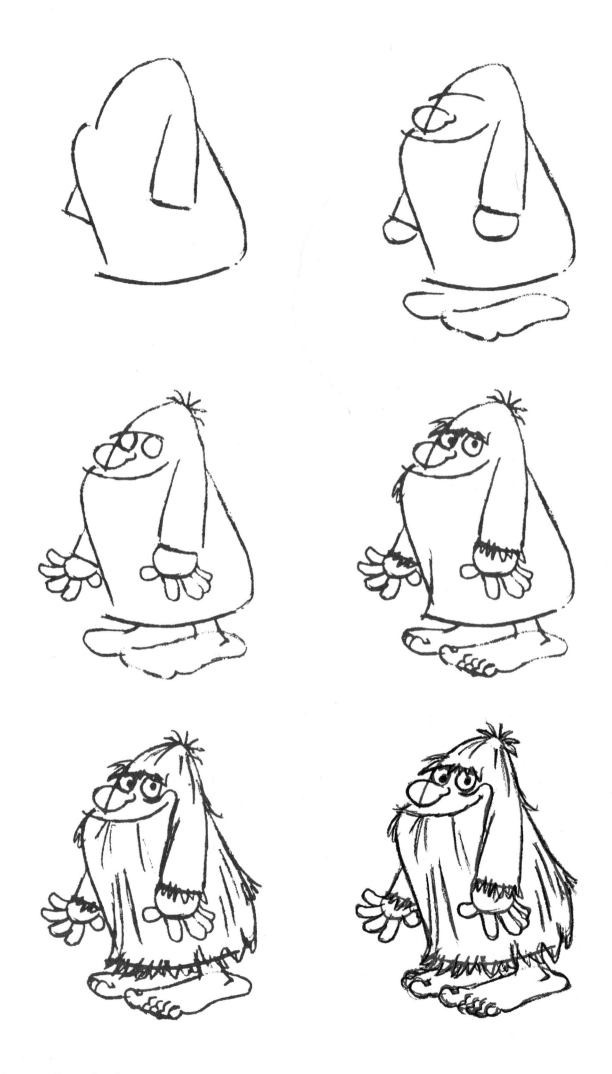

Whitcomb Woolly Whiskers

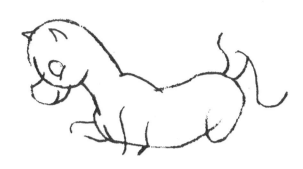

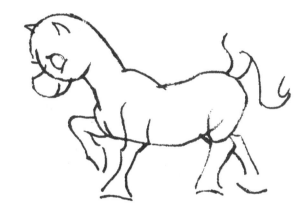
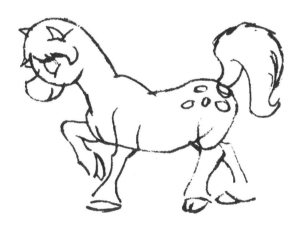
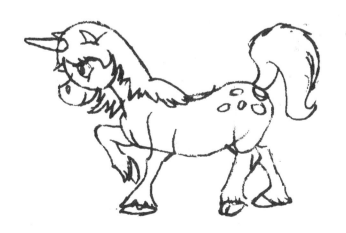
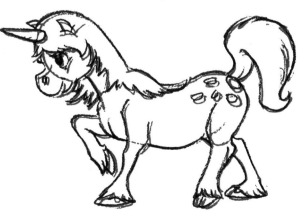

Eunice Corne

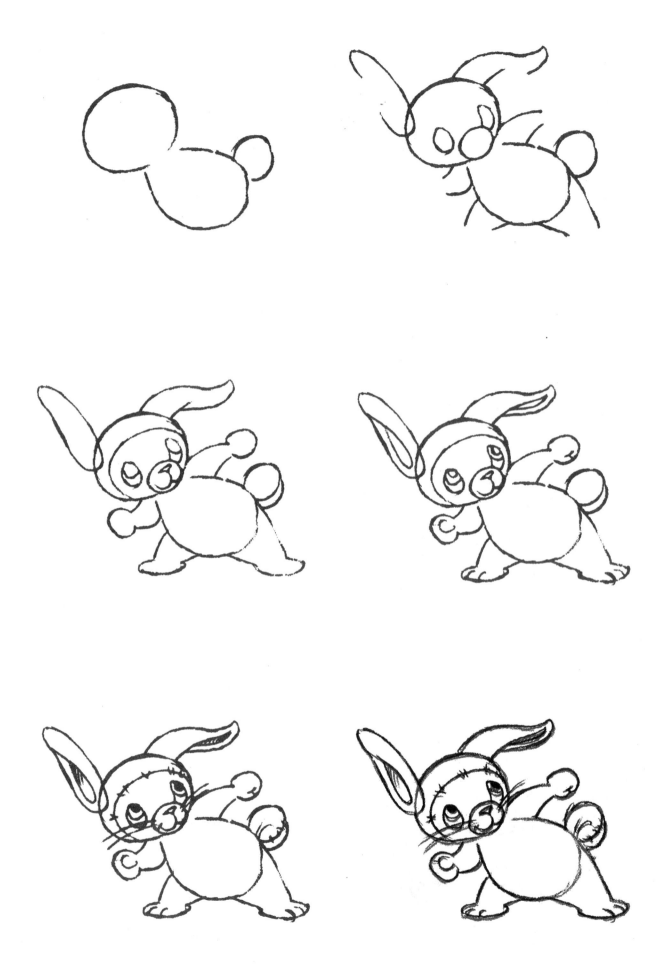

Bunny Beanbag

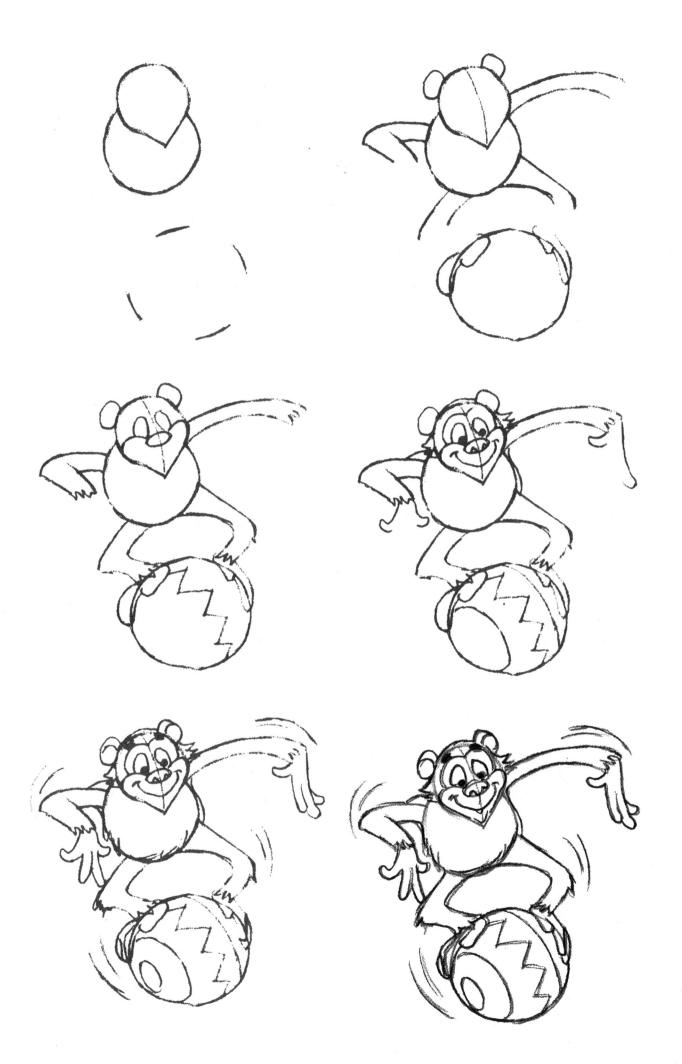

Funk Monkey, the Acrobat Junky

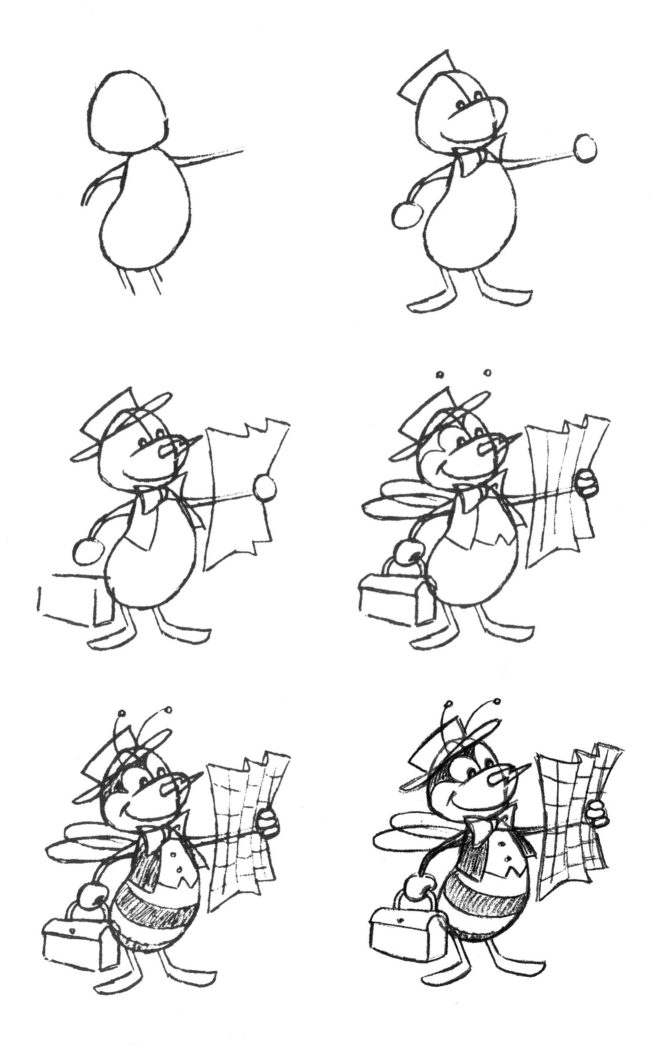

Traveling Sales Bee

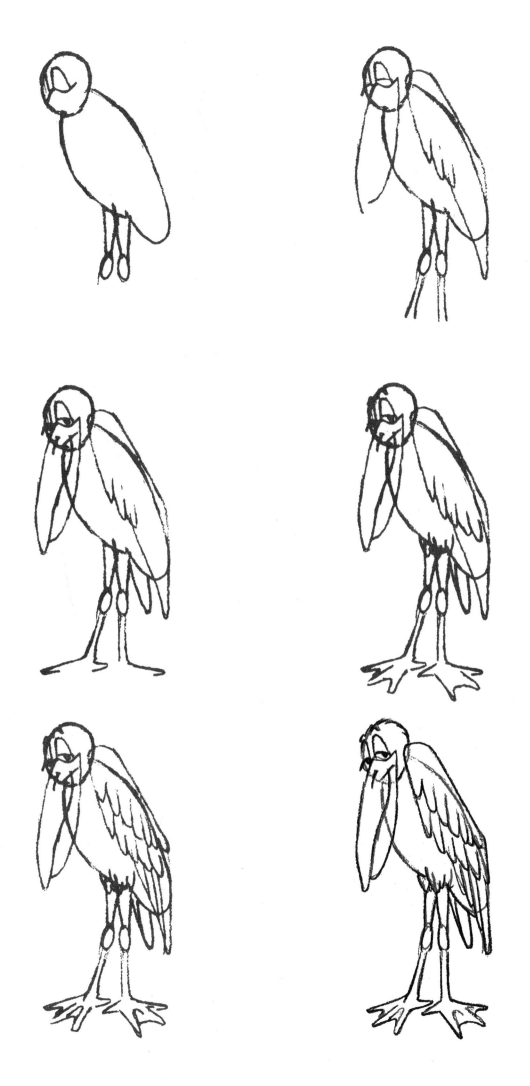

Sorry Sammy Stork

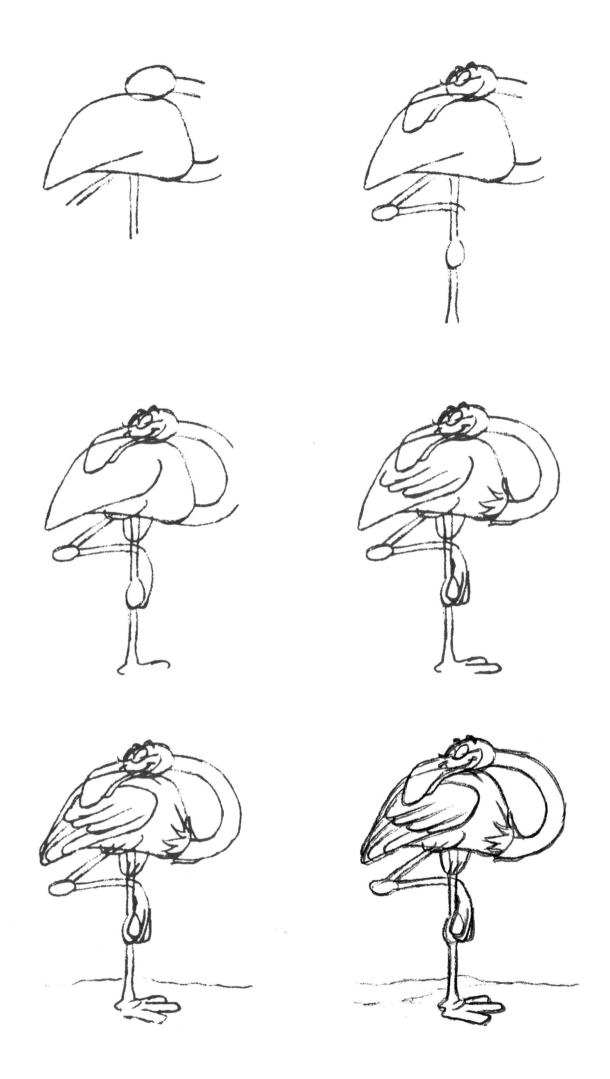

Wambingo Flamingo

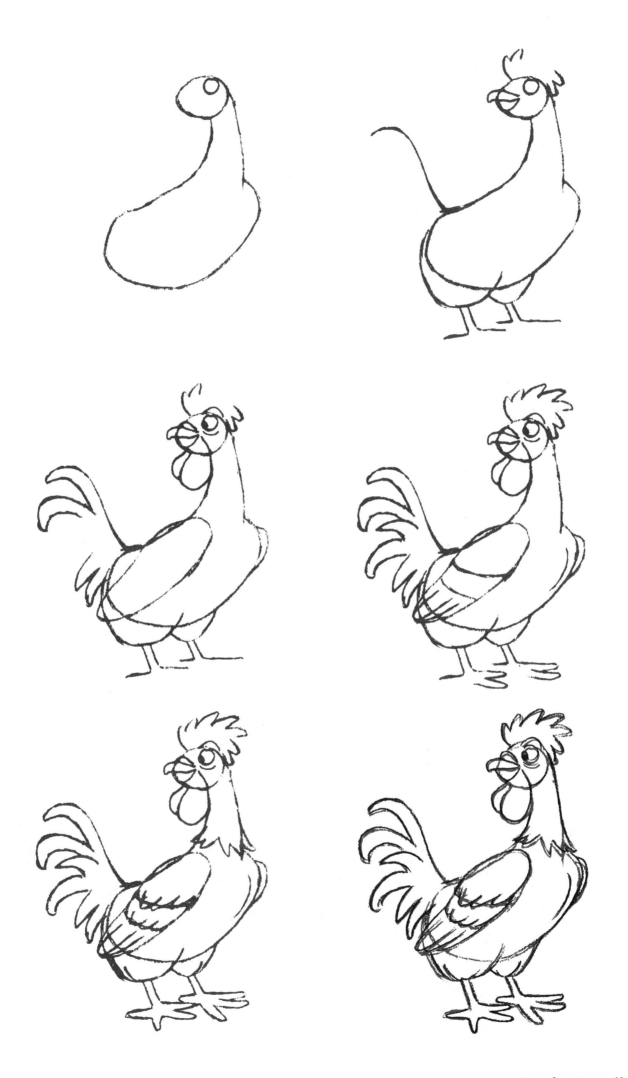

Kooky Doodle Doo

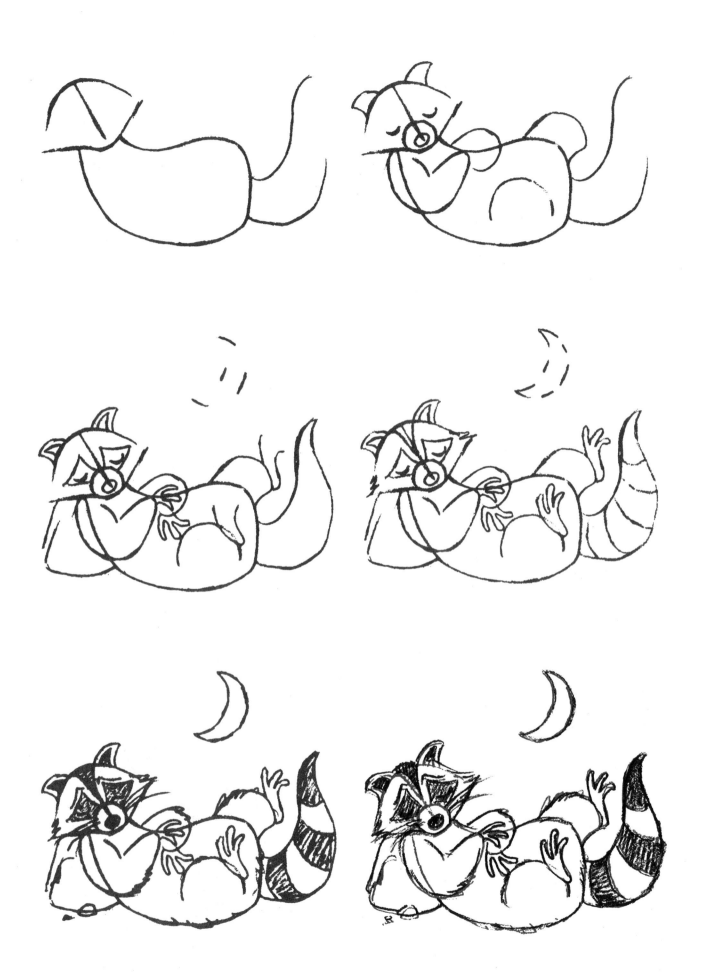

Sleepy Raccoon

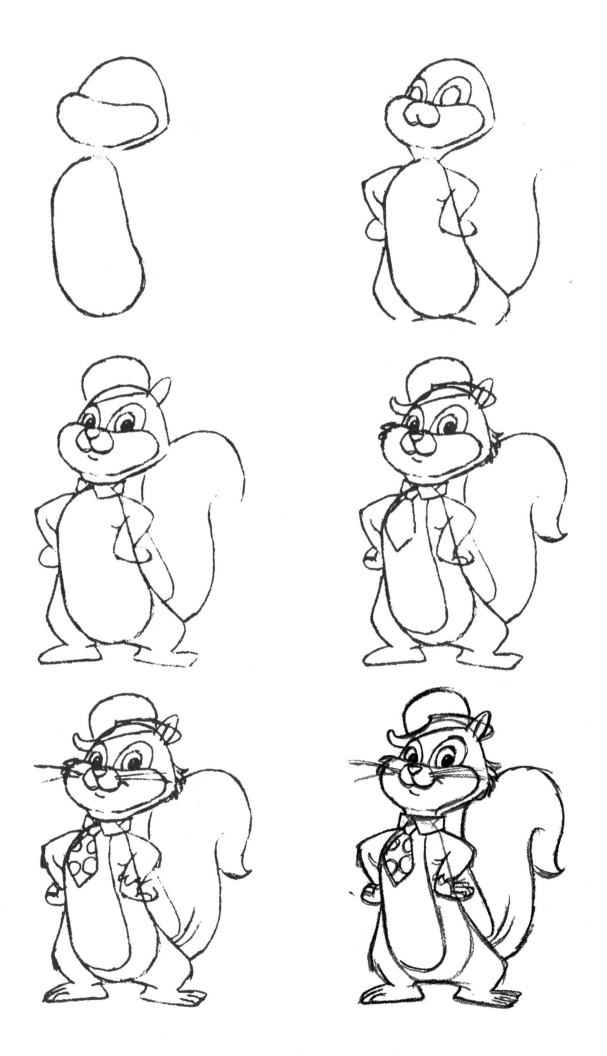

Squire Squiggly Squirrel

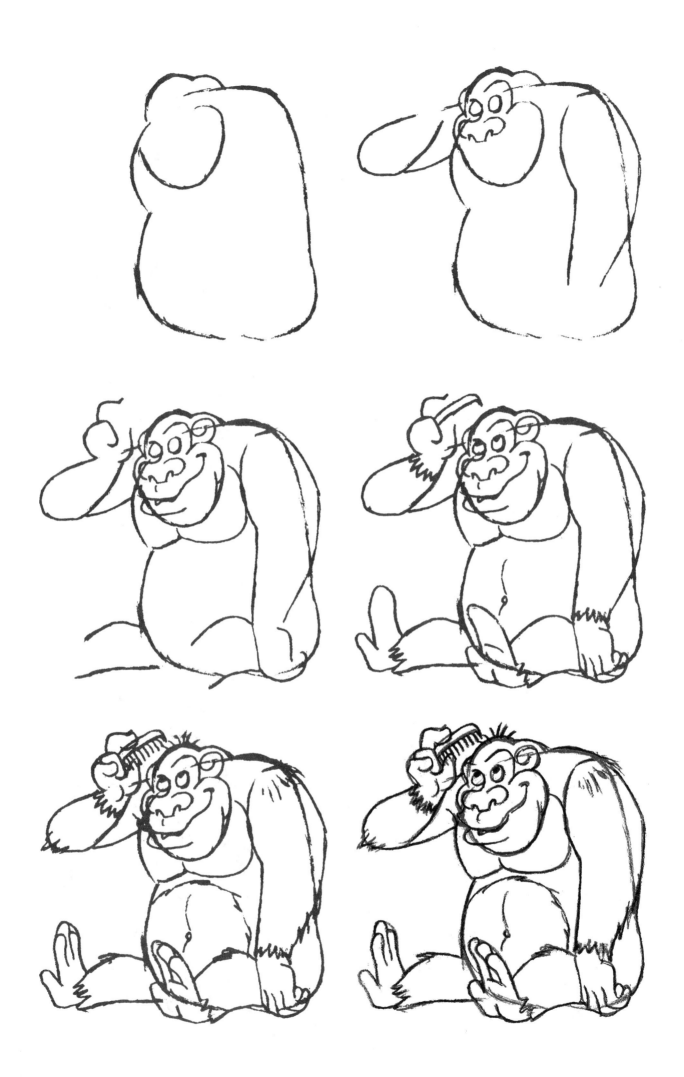

Sir Gareth, the Neat Gorilla

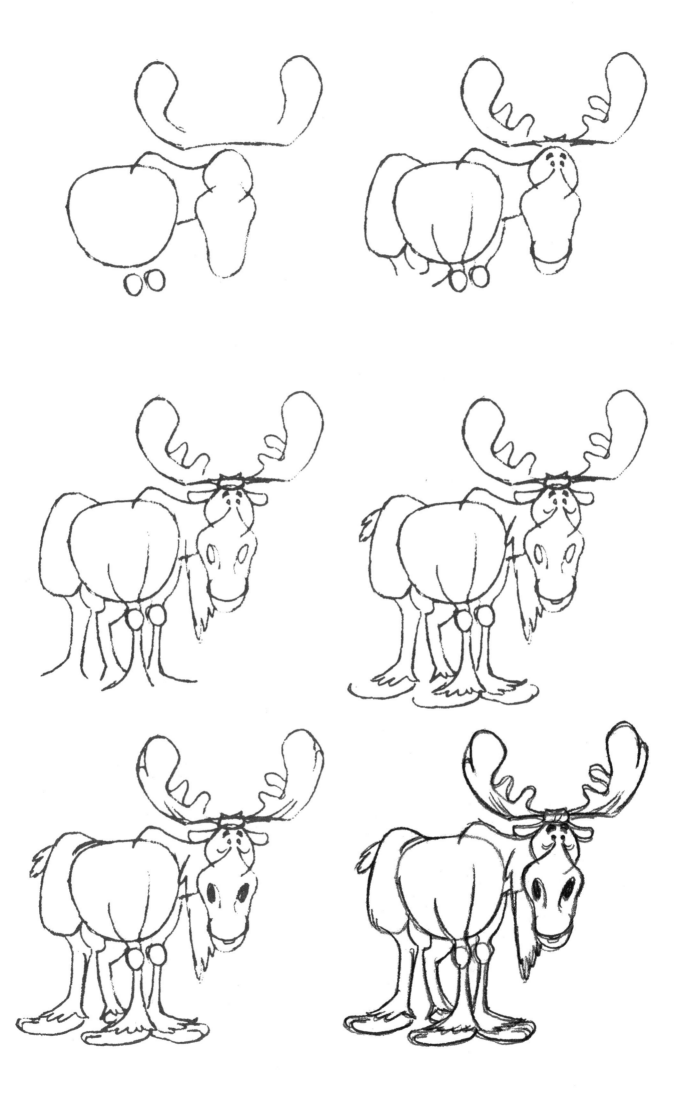

Muggy Moose

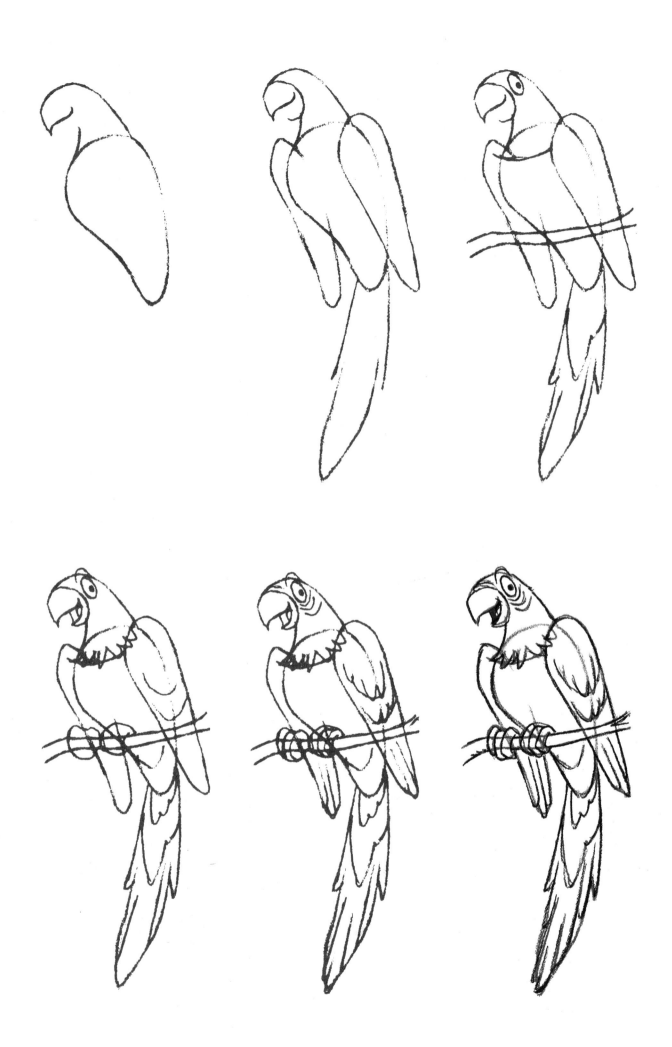

Squawkie Mouth Macaw

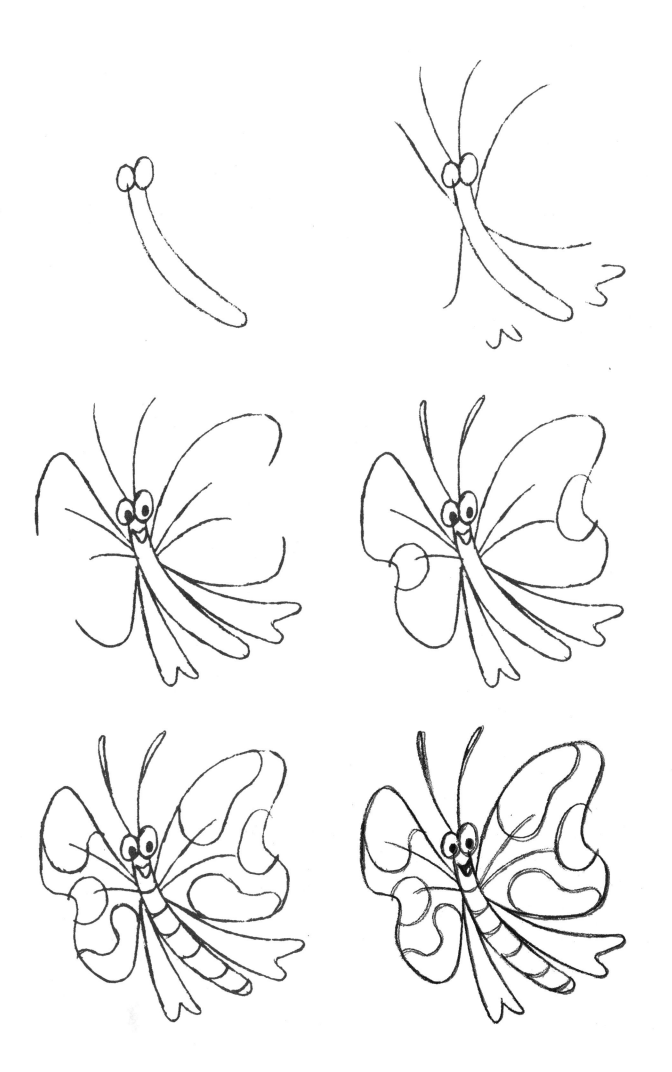

Fanny Flutter By

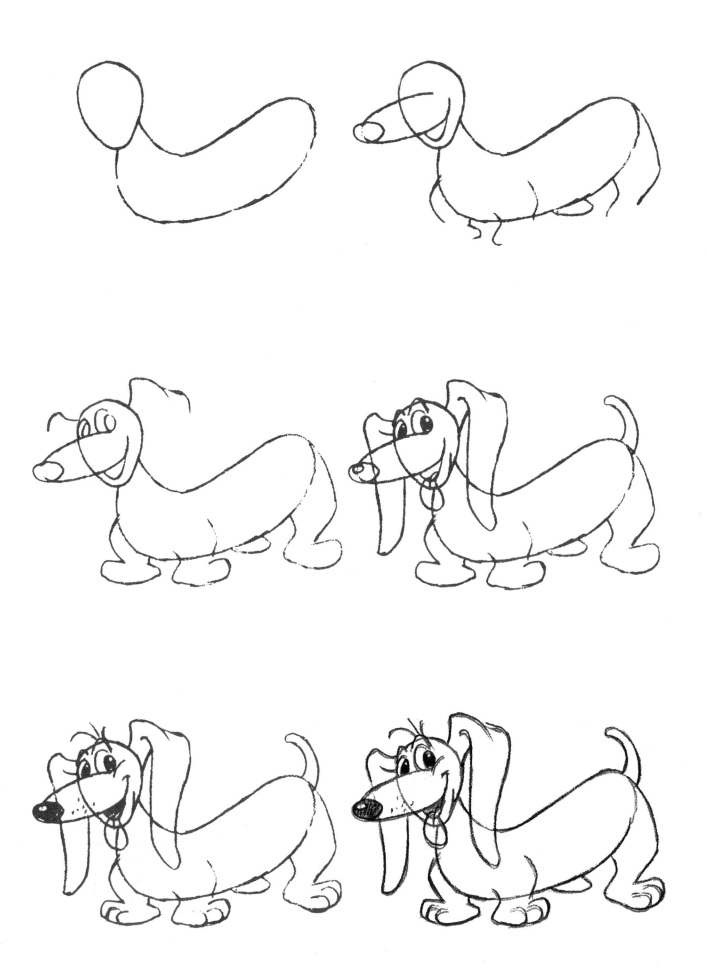

Frank E. Phooter

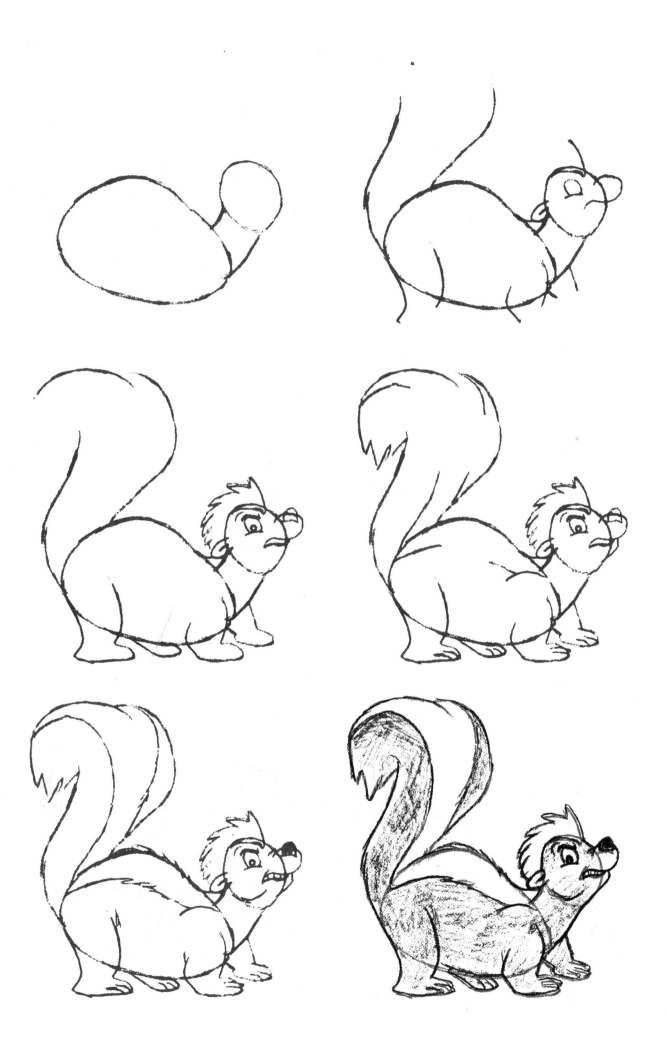

P. U. Polecat

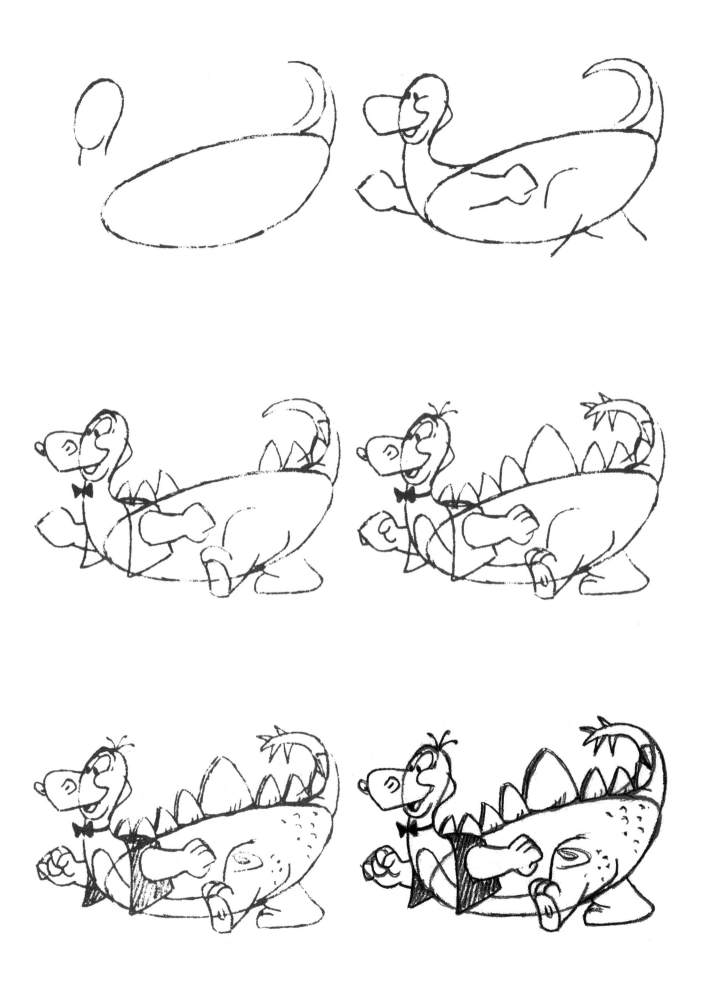

Steggy Sore Izz

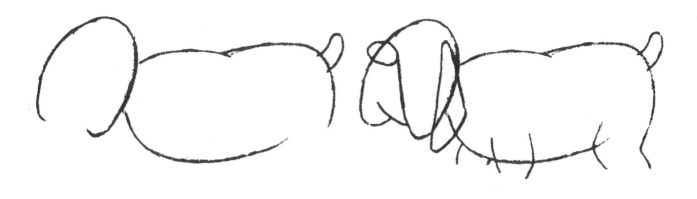

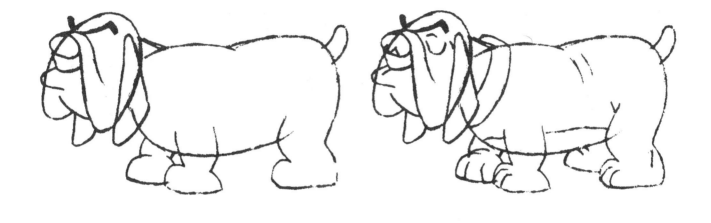

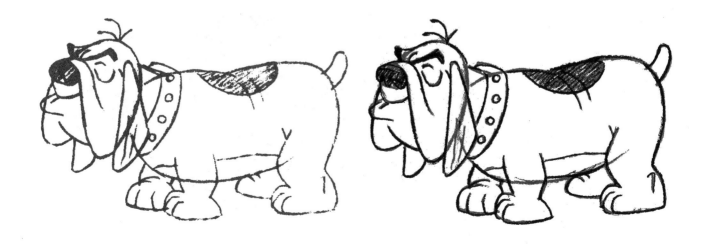

Winston Arrrf

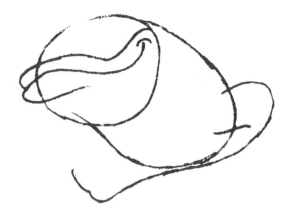
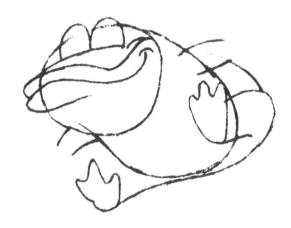
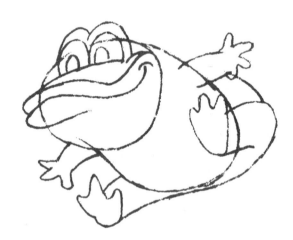
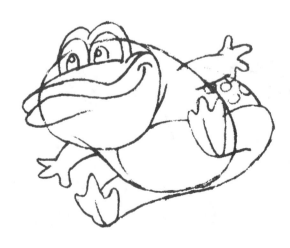
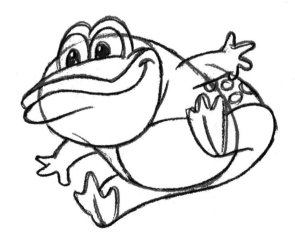

Jumpy Jed, the Bog Frog

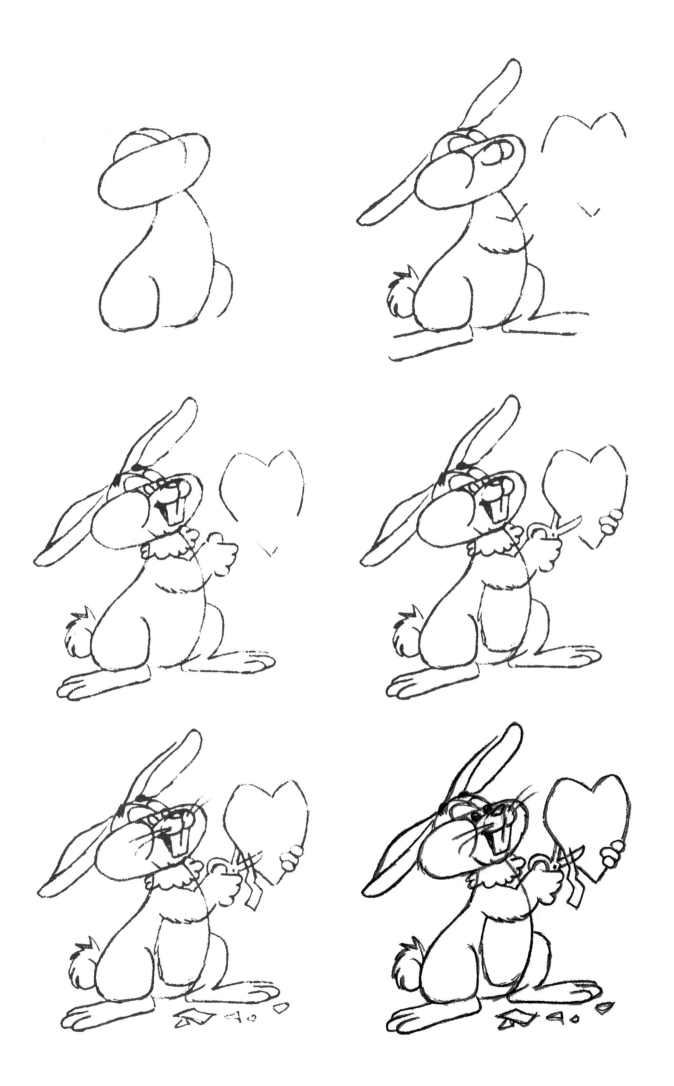

Cottontail Cutup

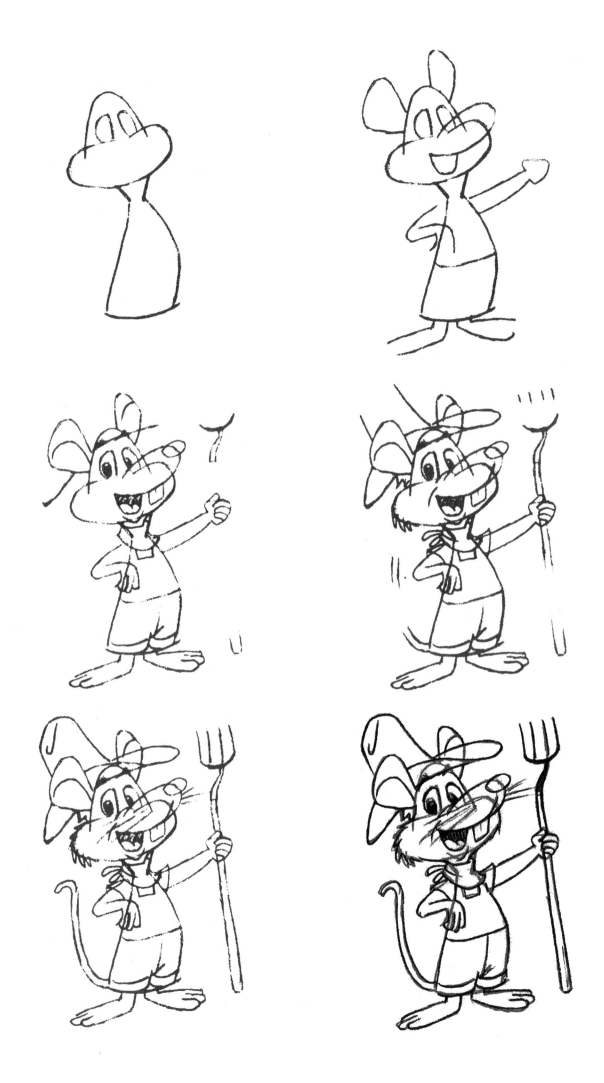

Caleb, the Country Mouse

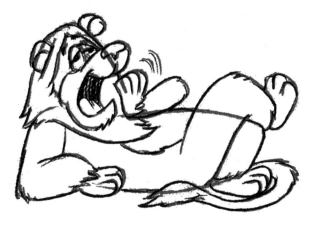

Lazy Leo

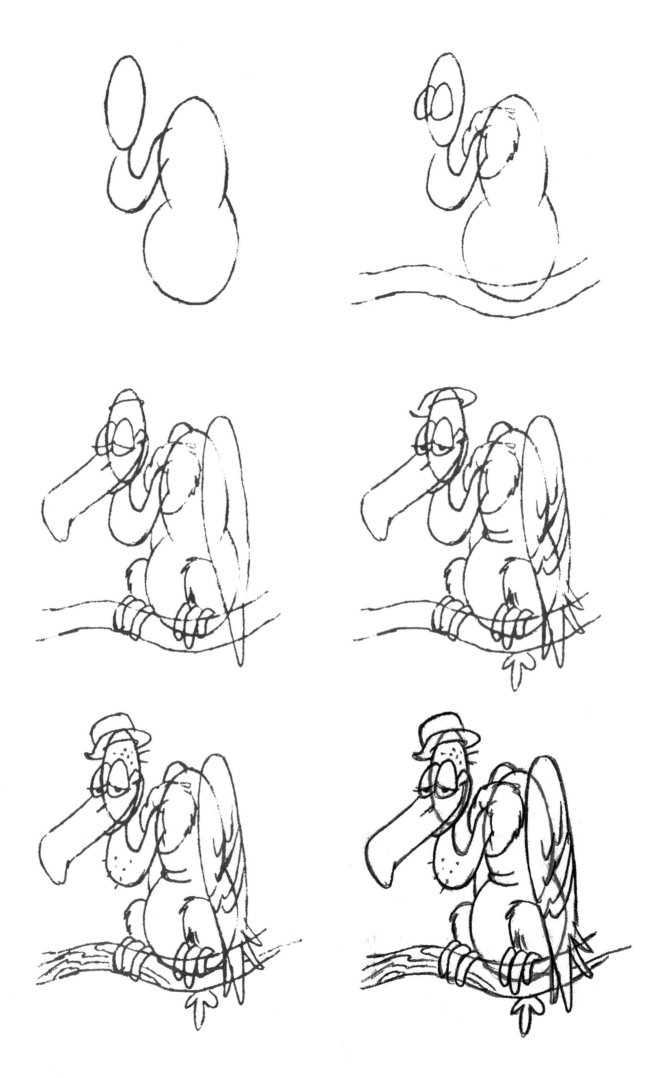

Caspar Condor

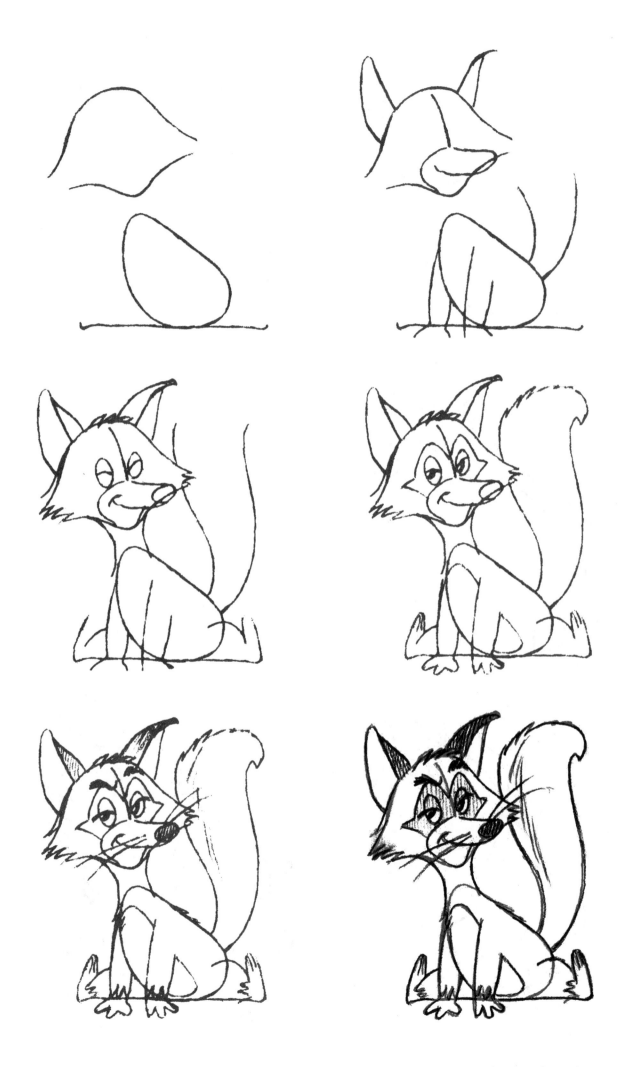

Tricky Ricky, the Fiddly Fox

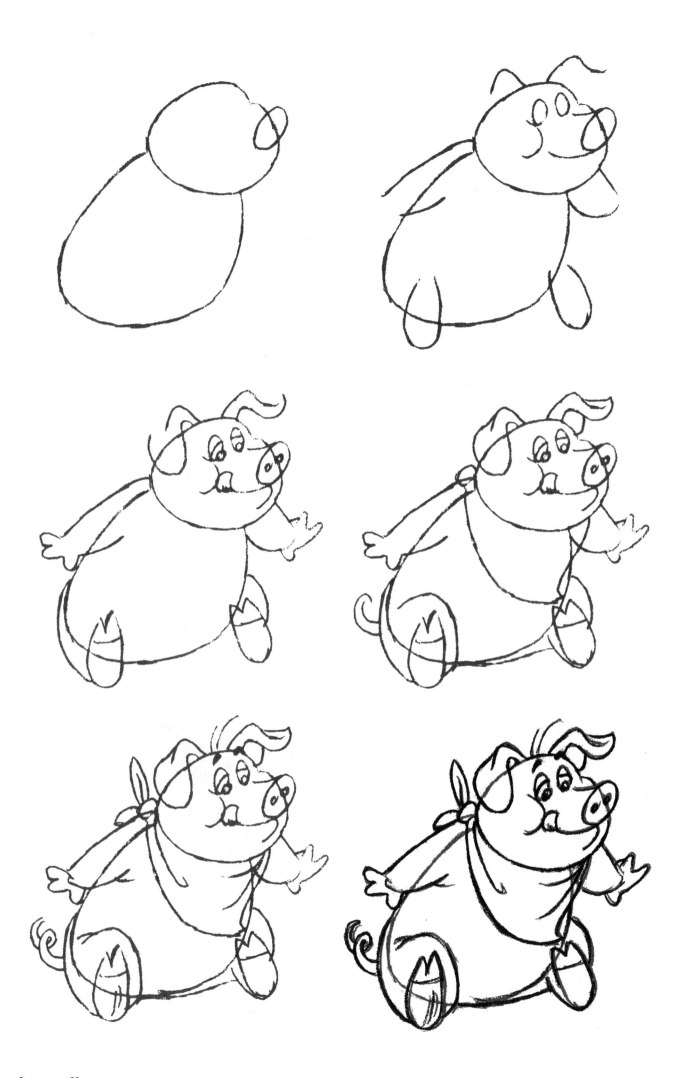

Munchie Millie

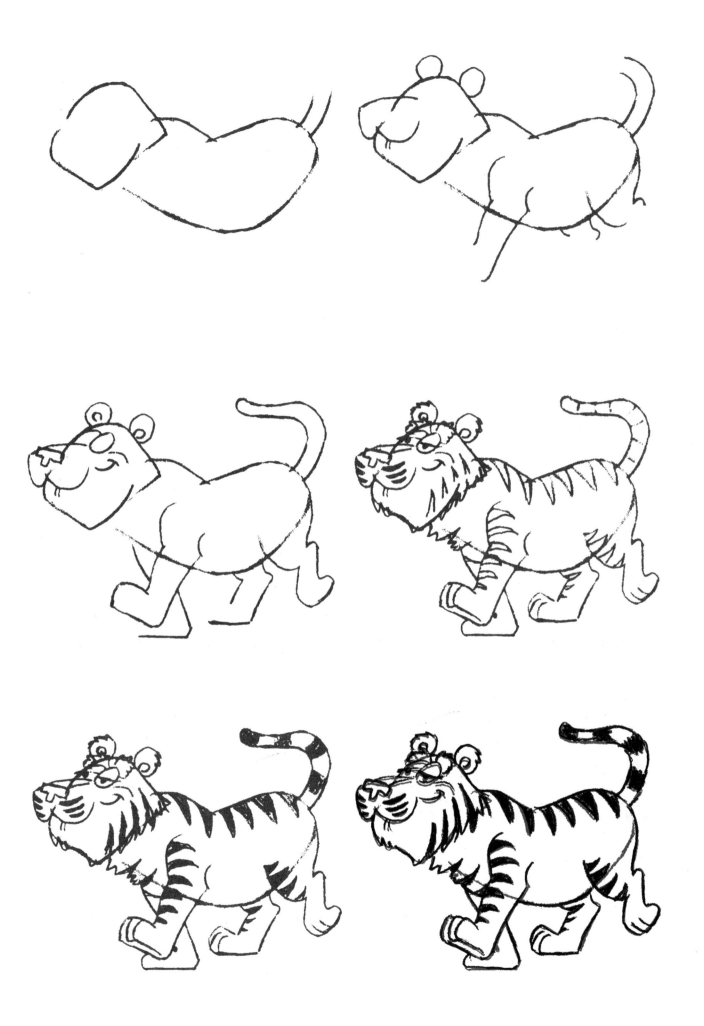

Stripes, the Trendy Tiger

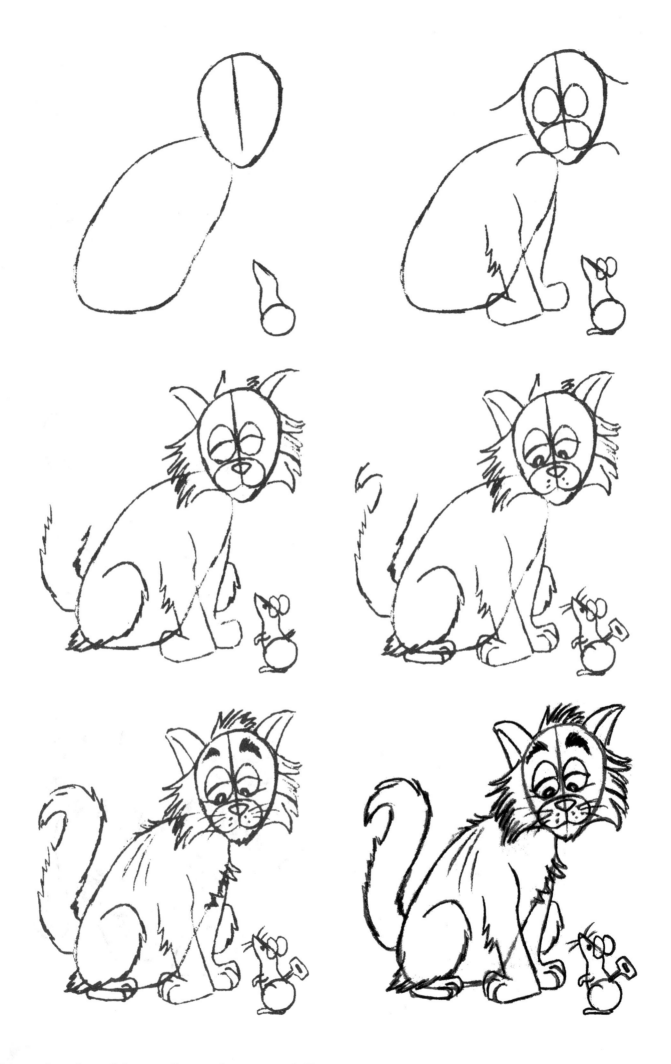

Taken Aback Tabby and Windup Wendell

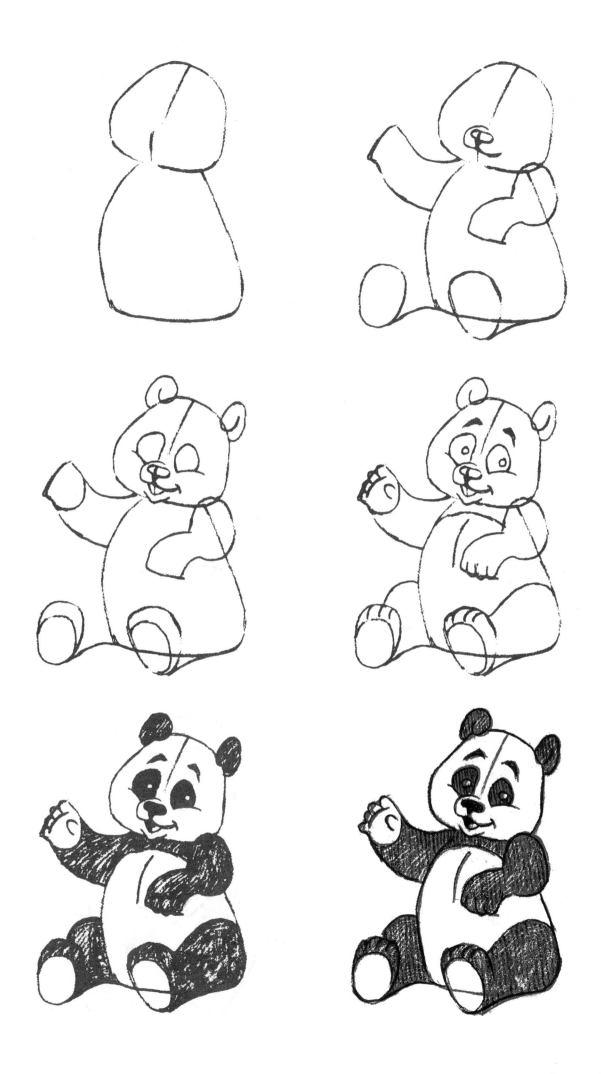

Amanda Panda

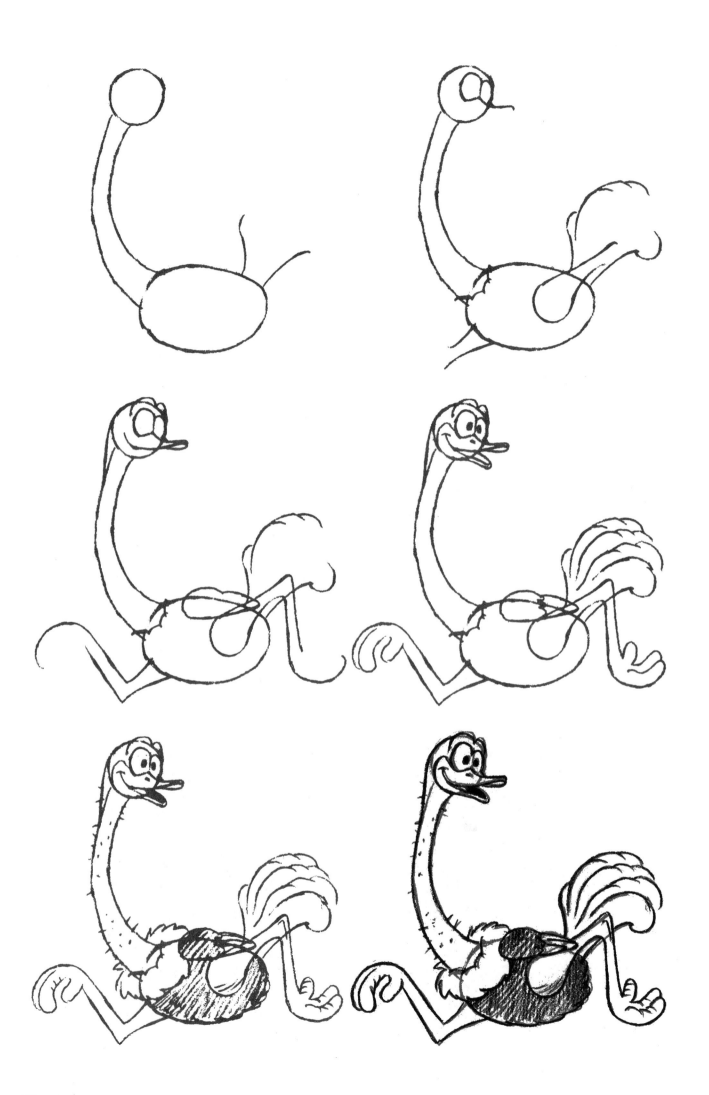

Olga Stretch

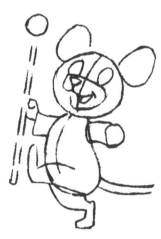
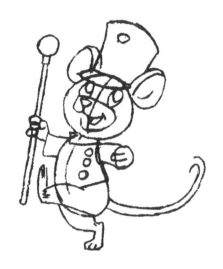
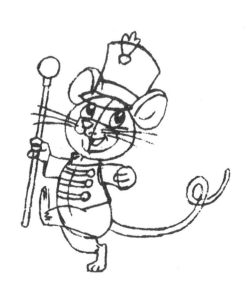
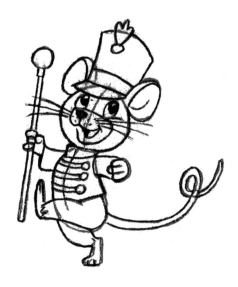

Martial Major Mouse

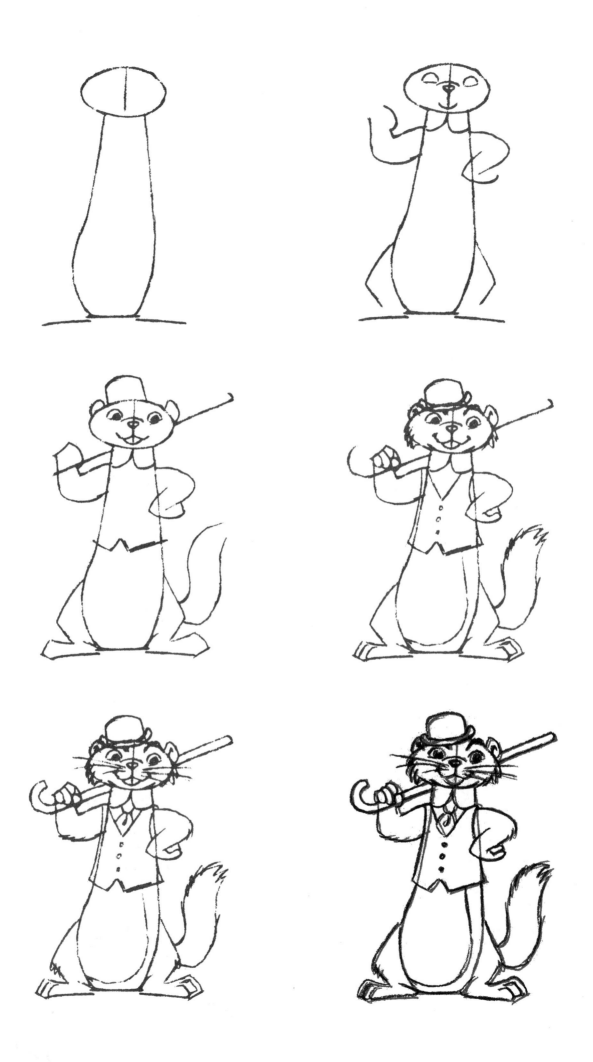

Wily Willy Weasel

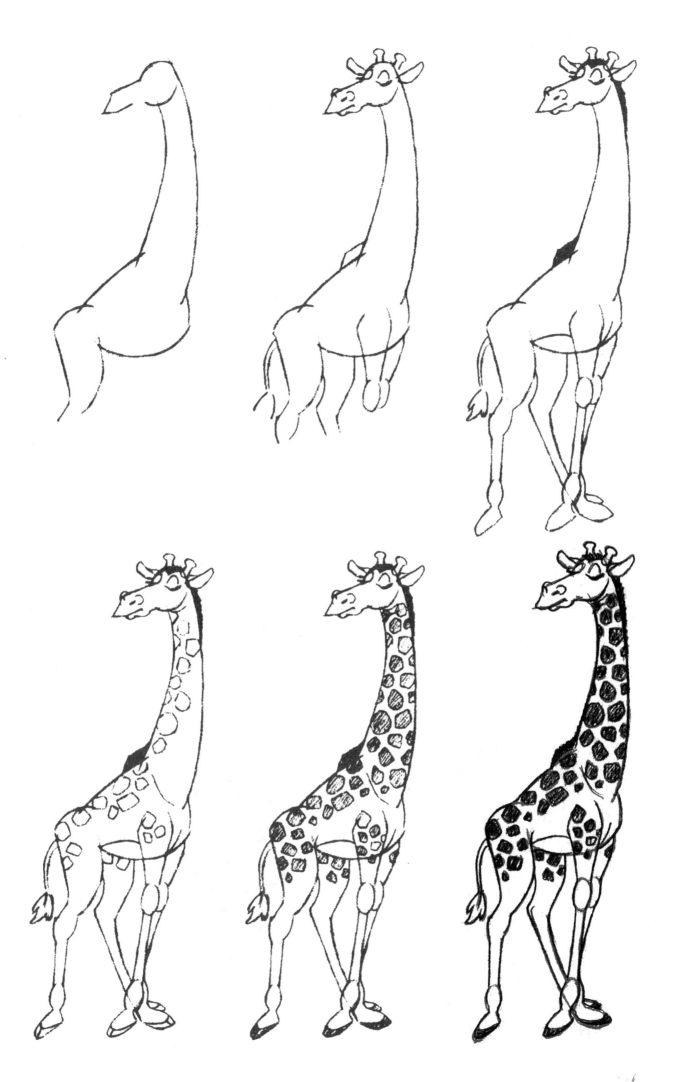

Lengthy Lenny Spots

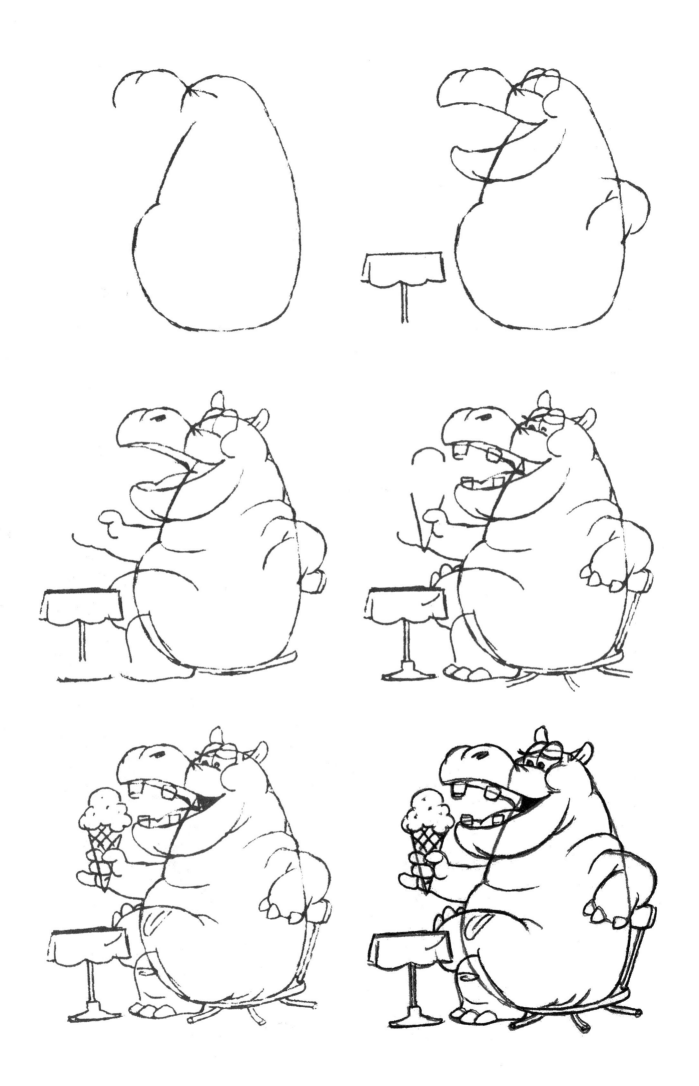

Happy Potta Mess

ABOUT BOB SINGER

Bob Singer was born in Santa Barbara, California, and spent his early years in nearby Santa Paula. He attended the Art Center School in Los Angeles, majoring in advertising illustration, and graduated in 1954 with honors and a B.P.A. degree.

After a year with the Carson/Roberts Advertising Agency, Bob entered the animation industry in 1956, working for such studios as Shamus Culhane, Warner Cartoons, UPA Pictures, Hanna-Barbera, and Marvel.

In the course of twenty-five years at Hanna-Barbera, he headed the layout department, founded the character design department, and later became art director for publicity. During this period he also taught evening classes in layout, character design, and storyboarding, and was a guest lecturer for film classes at the University of Southern California and several local elementary and high schools.

In 1988 Bob established his own company, Singer/Bandy Group, and for the next two years designed greeting cards, cassette covers, coloring books, plush dolls, picture puzzles, and illustrated storybooks for such clients as Hamilton Projects, Schmidt-Cannon, and MCA.

In 1990 Bob returned to Hanna-Barbera as a storyboard director and designer of animation cel art. He has been a member of the Academy of Motion Picture Arts and Sciences for over thirty-five years. At present, Bob is enjoying retirement, illustrating storybooks for Bedrock Press, creating merchandising drawings for Hanna-Barbera, and working as a consultant to the industry. He is the author of the book *How to Draw Animation Storyboards*, published in 1992. In 1998 Bob began a series of personal appearances at many Warner Bros.' retail stores, signing artwork and demonstrating the art of storyboarding. Thus far he has appeared in several cities across the country, and abroad in Hawaii and Australia.

DRAW 50 FOR HOURS OF FUN!

Using Lee J. Ames's proven, step-by-step method of drawing instruction, you can easily learn to draw animals, monsters, airplanes, cars, sharks, buildings, dinosaurs, famous cartoons, and so much more! Millions of people have learned to draw by using the award-winning "Draw 50" technique. Now you can too!

COLLECT THE ENTIRE DRAW 50 SERIES!

The Draw 50 Series books are available from your local bookstore. You may also order direct (make a copy of this form to order). Titles are paperback, unless otherwise indicated.

ISBN	TITLE	PRICE	QTY	TOTAL
23629-8	Airplanes, Aircraft, and Spacecraft	$8.95/$13.95 Can	× _____	= _____
49145-X	Aliens	$8.95/$13.95 Can	× _____	= _____
19519-2	Animals	$8.95/$13.95 Can	× _____	= _____
90544-X	Animal 'Toons	$8.95/$13.95 Can	× _____	= _____
24638-2	Athletes	$8.95/$13.95 Can	× _____	= _____
26767-3	Beasties and Yugglies and Turnover Uglies and Things That Go Bump in the Night	$8.95/$13.95 Can	× _____	= _____
47163-7	Birds	$8.95/$13.95 Can	× _____	= _____
47006-1	Birds (hardcover)	$13.95/$18.95 Can	× _____	= _____
23630-1	Boats, Ships, Trucks, and Trains	$8.95/$13.95 Can	× _____	= _____
41777-2	Buildings and Other Structures	$8.95/$13.95 Can	× _____	= _____
24639-0	Cars, Trucks, and Motorcycles	$8.95/$13.95 Can	× _____	= _____
24640-4	Cats	$8.95/$13.95 Can	× _____	= _____
42449-3	Creepy Crawlies	$8.95/$13.95 Can	× _____	= _____
19520-6	Dinosaurs and Other Prehistoric Animals	$8.95/$13.95 Can	× _____	= _____
23431-7	Dogs	$8.95/$13.95 Can	× _____	= _____
46985-3	Endangered Animals	$8.95/$13.95 Can	× _____	= _____
19521-4	Famous Cartoons	$8.95/$13.95 Can	× _____	= _____
23432-5	Famous Faces	$8.95/$13.95 Can	× _____	= _____
47150-5	Flowers, Trees, and Other Plants	$8.95/$13.95 Can	× _____	= _____
26770-3	Holiday Decorations	$8.95/$13.95 Can	× _____	= _____
17642-2	Horses	$8.95/$13.95 Can	× _____	= _____
17639-2	Monsters	$8.95/$13.95 Can	× _____	= _____
41194-4	People	$8.95/$13.95 Can	× _____	= _____
47162-9	People of the Bible	$8.95/$13.95 Can	× _____	= _____
47005-3	People of the Bible (hardcover)	$13.95/$19.95 Can	× _____	= _____
26768-1	Sharks, Whales, and Other Sea Creatures	$8.95/$13.95 Can	× _____	= _____
14154-8	Vehicles	$8.95/$13.95 Can	× _____	= _____
	Shipping and handling	**(add $2.50 per order)** × _____		= _____
		TOTAL		_____

Please send me the title(s) I have indicated above. I am enclosing $_____.

Send check or money order in U.S. funds only (no C.O.D.s or cash, please). Make check payable to Random House, Inc. Allow 4–6 weeks for delivery. Prices and availability subject to change without notice.

Name: _____

Address: _____ Apt. #_____

City: _____ State: _____ Zip: _____

Send completed coupon and payment to:

Random House, Inc.
Customer Service
400 Hahn Rd.
Westminster, MD 21157

BROADWAY